Pring's

PHOTOGRAPHER'S MISCELLANY

Pring's

PHOTOGRAPHER'S
MISCELLANY

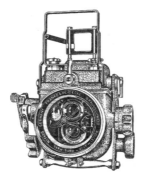

STORIES, TECHNIQUES,
TIPS & TRIVIA

ILEX

First published in the UK in 2011 by

I L E X

210 High Street
Lewes
East Sussex BN7 2NS
www.ilex-press.com

PUBLISHER Alastair Campbell
CREATIVE DIRECTOR Peter Bridgewater
ASSOCIATE PUBLISHER Adam Juniper
MANAGING EDITOR Natalia Price-Cabrera
EDITORIAL ASSISTANT Tara Gallagher
ART DIRECTOR James Hollywell
DESIGNER Roger Pring
COLOUR ORIGINATION Ivy Press Reprographics

British Library Cataloguing-in-Publication Data
A catalogue record for this book
is available from the British Library

ISBN 13: 978-1-907579-43-1

Printed and bound in China

10 9 8 7 6 5 4 3

"I drifted into photography like one drifts
into prostitution. First I did it to please
myself, then I did it to please my friends,
and eventually I did it for the money."

PHILIPPE HALSMAN

❧

*The author would like
to acknowledge the following:*

*Sheila Baker, Oli and Colin Fox,
Richard Cynan Jones, Sarah Pring
and Tarja Trygg*

❧

SNAP

THE FIRST RECORDED USE of "snapshot" was by Sir Henry Hawker, according to the Oxford English Dictionary. The reference was to his recently shot bag of game, largely achieved "by snapshot, a hurried shot, taken without deliberate aim." "Snap" comes from 15th-century Dutch and Low German, based on *snavel*—a bird's bill or beak.

IN THE BEGINNING

JOSEPH NIÉPCE (born 1765 in Chalon-sur-Saône, France) changed his first name to Nicéphore in honor of St Nicephorus of Constantinople. The English now glumly acknowledge that he invented photography, rather than their hero, Fox Talbot. With his brother Claude, Niépce also invented the *Pyréolophore*, an internal-combustion engine running on dust derived from a species of moss.

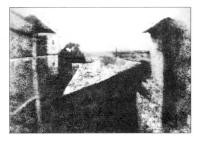

In 1825, he managed to fix this photographic image using bitumen dissolved in lavender oil. The exposure in a camera obscura ran to eight hours, and shows the view across the courtyard at his home. His later collaboration with Louis Daguerre produced the *Physautotype*, also using the ubiquitous lavender oil. After Niépce's death in 1833, Daguerre went on to devise a more practical method, the patent for which was bought by the French government, and Niépce's descendants were eventually voted a pension in appreciation. A forbiddingly large stone monument stands at the side of the Route Nationale 6 just outside Saint Loup de Varennes, boldly asserting in very tall capital letters that "in this village, Nicéphore Niépce invented photography in 1822."

"Anything more than 500 yards from the car just isn't photogenic."
EDWARD WESTON

LEITZ AND BARNACK

ERNST LEITZ (b. 1906) JOINED the family optical business aged 18 as an apprentice and was appointed managing director at the age of only 24. At the end of World War I, the head of camera development at the Leitz company was Oskar Barnack, an asthmatic engineer looking for a lightweight alternative to the bulky plate-cameras, tripods and associated equipment of the time. Ernst Leitz approved Barnack's prototype camera in 1923. It used the 35mm cinéfilm format which had been standardized in 1909, but by running the film horizontally through the camera, the usable frame size was doubled—to 24 × 36 mm. A production version named Leica I (for *Leitz camera*) was finally put on sale in 1925. Later refinements included a rangefinder and an extended range of shutter-speeds. Several variations of the original design were produced until 1960, and were superseded by the M-series cameras.

Oskar Barnack's original "Ur-Leica," made in 1913.

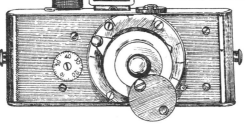

AN UNLIKELY COMBINATION

HENRY PEACH ROBINSON and Oscar Gustave Rejlander were the first practitioners of "combination printing" in which meticulously planned negatives were cut together to form a montage, sometimes a moral narrative, but very often of domestic scenes involving sickness and death. Robinson operated in Leamington Spa as a portrait photographer, while Rejlander was in Wolverhampton gaining a reputation for erotic photography. Both were founding members of the Birmingham Photographic Society, but Robinson became seriously ill from exposure to darkroom chemicals and had to give up studio work aged only 34. Rejlander finally redeemed his dubious reputation by selling a ten-guinea print of an improving nature to Queen Victoria.

ANIMAL LOCOMOTION

EADWEARD J. MUYBRIDGE (born Edward James Muggeridge in England in 1830) is known for his photographs of people and animals in motion. Working in 1855 as a bookseller in San Francisco, he returned to England after an injury in a stagecoach accident. Back in the USA in 1866, he met the former State Governor, Leland Stanford, who wanted to resolve an argument about whether a galloping horse's hooves ever completely leave the ground, and commissioned Muybridge in 1872 to provide the evidence.

Five years of experiment produced the definitive sequence, a period in which Muybridge found time to murder his wife's lover (probable father of his young son) and be acquitted on the grounds of justifiable homicide. Muybridge and Stanford later fought over Leland's publication of the images (*see p. 63*), but Muybridge acquired new patrons. Their support enabled his masterwork *Human and Animal Locomotion*. Muybridge recycled the stop-motion idea to make a "Zoopraxiscope," a sequence of pictures pasted inside a rotating drum. Viewed from the outside, slits in the drum momentarily reveal each image, giving the illusion of motion through persistence of vision. Muybridge returned to England in 1894 and died ten years later in Liverpool.

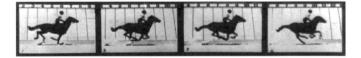

ACRONYMS: A

APO APOCHROMATIC: the ordinary convex lens focuses different wavelengths (colors) of light at different distances behind the lens, giving a soft image. The apochromatic lens has three or more elements cemented together, and focuses the different wavelengths into a sharp image on a common plane.

APS ADVANCED PHOTO SYSTEM: a film format and camera system introduced in 1996. It featured a disposable cassette resembling the familiar 35mm container, though with a smaller usable film area. Ultimately overtaken by the advent of digital cameras and now effectively obsolete.

ASA AMERICAN STANDARDS ASSOCIATION: a numerical measure of film sensitivity. Thus, 50 ASA, a "slow" film, denotes a relatively insensitive (though fine-grained) emulsion, while 800 ASA (more coarse-grained) "fast" film is designed to be used in low light conditions.

―――――― INSTANT GRATIFICATION ――――――

EDWIN HERBERT LAND (b. 1909) invented the world's most successful instant-picture system in 1947. He had previously failed to complete his degree at Harvard, but did succeed in developing a polarizing film which found applications in photography and, more profitably, in making sunglasses. Land worked for the military during World War II, producing goggles for enhancing night-vision, and a viewing system to assist the interpretation of aerial photographs. The 1947 Land Camera (black-and-white only) sandwiched the exposed negative with a second sheet which would become the finished print. The sandwiched sheets passed through rollers which spread a chemical compound between them. During a minute's development (longer in cold weather) the negative image is transferred to the print sheet.

After many more years' experimentation, instant color photography arrived in 1963. An extremely complex sandwich comprised a negative with layers sensitive to red, green, and blue light. Under each of these is a dye layer in the complementary color—cyan, magenta, and yellow respectively. Red light falling on the red-sensitive layer, for example, is blocked from reaching the underlying cyan dye, but passes through to the other two layers, magenta and yellow. On development, effected by pulling the sandwich out of the camera through pressure rollers, the activated magenta and yellow dyes combine to produce red. The SX-70 camera, introduced in 1972, used a new film which was automatically ejected from the camera after exposure, and revealed the image in daylight. The Polaroid Corporation was engulfed by the arrival of digital imaging and filed for bankruptcy protection in 2001. The Polaroid brand is still in use, but production of instant-picture cameras and film had ceased by 2009.

―――――― ARTHUR FELLIG ――――――

BETTER KNOWN AS WEEGEE, Arthur (originally Usher) Fellig arrived in New York from the Ukraine with his family in 1909. In the 1930s he began photographing the city's street life, and by 1938 had acquired a police-band radio in his car, with the blessing of the authorities. His apparent prescience in arriving at the scene of murders and accidents gained him the Weegee nickname (derived from the spiritualists' "Ouija" board). Equipped with a 4 × 5 inch Speed Graphic camera, a pocketful of flashbulbs and a complete dark-room in the trunk of his car, he dominated the New York newspaper photo scene for two decades, later becoming a consultant (and actor) in Hollywood. He is credited as the stills photographer on the movie *Dr. Strangelove* or: *How I Learned to Stop Worrying and Love the Bomb*.

BOKEH

A JAPANESE WORD FOR SENILITY or dizziness, and, by extension, haze or blur, but in photographic terms it refers to the different qualities of out-of-focus effects seen in the background of pictures with a shallow plane of focus. It is distinguished from simple blur by the appearance, for example, of distinctly shaped out-of-focus highlights. These are usually formed as a function of the shape of the lens aperture at the moment of exposure. At full aperture, the highlights appear circular, but a stopped-down lens (with a conventional bladed aperture mechanism) can produce polygonal highlights with the same number of sides as blades in the lens. So-called "good" bokeh has these highlight edges softly rendered, and therefore not distracting from the focused image. High-quality lenses tend to have curved aperture blades, which decrease the polygonal appearance.

> *"I have often thought that if photography were difficult in the true sense of the term—meaning that the creation of a simple photograph would entail as much time and effort as the production of a good watercolor or etching—there would be a vast improvement in total output. The sheer ease with which we can produce a superficial image often leads to creative disaster."*
>
> ANSEL ADAMS

BLINKING IN THE LIGHT

THE EXTREMELY INSENSITIVE emulsions available in the early days of photography led to extended exposure times, even though newly built "daylight studios" were equipped with with large skylights. Portrait sitters routinely had their heads clamped immobile until the introduction of an artificial light source borrowed from the theater, and slowly improving emulsions allowed shorter exposures. Using "limelight" involved heating a lump of lime (calcium carbonate) in an oxygen-rich flame. However, the intense, unsympathetic light gave a ghoulish appearance to portraits as the sitters squinted and winced. One solution proved to be magnesium ribbon or powder, giving a briefer burst of light, but this also filled the studio with toxic fumes. It was not until the late 1870s that an electric-powered system, using arc-lights, became a practical proposition for studio photography.

CAREER PROSPECTS

IN 2009, THE BUREAU of Statistics of the US Department of Labor estimated that there were 39,570 professional photographers in the USA, earning an annual average (mean) of $33,790. There were twice as many people working as dentists, making an average of just over $150,000 annually. At the same time there were 759,200 lawyers enjoying a median $110,590 per annum. Operators of photographic processing equipment can expect to get an average $10.74 an hour.

ONKA-BONKA

A COLLOQUIAL TERM used by movie and TV studio lighting technicians: a kind of universal joint for extending a lighting set-up. In the absence of an onka-bonka, gaffer tape can be used to achieve a temporary fix.

PIGEON CAM

JULIUS NEUBRONNER, a German pharmacist, used homing pigeons to collect prescriptions and deliver the required medications, the lighter items only, to a local sanatorium. Bemused by the delay of a month in the return of one of his pigeons, he decided to equip the bird with a lightweight camera of his own design in order to discover what the bird had been doing.

Equipped with the new contraption, the pigeon was released around 60 miles from its home loft, and a pneumatic timer operated the shutter after a pre-set interval. Neubronner's efforts to secure a patent were eventually rewarded, but the outbreak of World War I saw all his pigeons and equipment, including twin-lens and stereoscopic devices, commandeered by the military. Reconnaissance by pigeon was not a success, so the birds reverted to their rôle as messengers. Reports suggested that a number of pigeons were captured by starving soldiers.

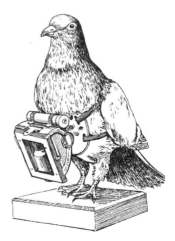

TREASURE TROVE

A CACHE OF GLASS PLATES apparently by Ansel Adams, was unearthed at a garage sale in 2010, and claimed to be worth over $200 million. The Ansel Adams Foundation condemned them as fakes. Genuine prints bought from the Ansel Adams gallery, complete with certificate of authentication, run from $5,000 to over $50,000. Relatives of two other photographers now claim the plates were produced by their ancestors. The case continues.

BY A NOSE

THE PHOTO-FINISH CAMERA secures the required image by moving the film laterally past a vertical slit facing the action. The film is transported at approximately the same speed as the subject, but if it moves more slowly, the typically elongated image occurs. Modern digital photo-finish cameras operate at an equivalent shutter speed of 1/2000 sec, and are linked to a computer which rapidly analyzes the image. The first recorded triple dead-heat in harness-racing (trotting) occurred in October 1953.

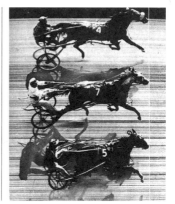

IMAGES FROM THE PAST

OLD CAMERAS ARE OFTEN found with exposed film in them. In the years following the exposures, cosmic radiation will have produced a background fog on the film, thereby lowering the contrast ratio. Typically, an early roll of Kodak Verichrome Pan (introduced in 1956) and developed half a century later is likely to yield an image of sorts. Experts recommend a cooler-than-usual development régime for a shorter time. The resulting negatives seem to darken after processing, so urgent printing is advised. Color transparency films of a similar age present a different problem. The dyes used to develop Kodachrome, for example, are no longer made, but the film can be processed to produce a black-and-white image. Old Ektachrome film can still be processed, usually as a color negative, then digitally transferred.

TO MAKE AN ALBUMEN *coating suitable for glass plates:*

Take a pound of lump sugar, and dissolve it in half a pint of clean rain-water, then boil the solution for five minutes, and pour it into a stock-bottle for use.

Select always the largest eggs, and as fresh as they can be had. If it is intended to work upon stereoscopic plates, one or two eggs will be quite sufficient to use at a time, as, although the mixture will generally keep for a month or more, it sometimes becomes deteriorated much sooner; it is, therefore, advisable not to tax its keeping qualities severely.

Albumen (one egg)	*1 ounce*
Sugar syrup	*½ ounce*
Iodide of potassium	*7 grains*
Bromide of potassium	*3 grains*
Rain water	*1 drachm*

The iodide and bromide should first be dissolved in the water, then added to the other ingredients, and the whole placed in a six or eight ounce bottle, which must be shaken vigorously until it is all reduced to a froth. This must be laid aside for at least forty-eight hours, when it should be filtered into a clean bottle, and a small piece of camphor added.

FROM THE *PHOTOGRAPHIC NEWS*, FEBRUARY 22, 1861.

SILVER LINING

SILVER-BASED MONOCHROME photographic film comprises a support made of polyester or cellulose acetate covered with an emulsion containing a layer of silver-halide salts. During development, a chemical reaction renders the silver component more or less black according to the original exposure. A water wash is followed by immersion in fixer. It is at this point that the surplus (unexposed) silver is washed out, and can be recovered, for example, by running the spent fixer into a container packed with steel wool. The resulting sludge can be simply refined to make metallic silver once again. A properly maintained system is capable of recovering over 90 percent of the original embedded silver. Electrical deposition and ion exchange are also used for larger-scale operations, and recovery is equally possible from redundant X-ray films by incinerating them and recovering the silver from the ashes. A less polluting and more efficient method uses bacterially produced enzymes to separate the silver, which is then coagulated with aluminum sulfate. Other by-products are more difficult to treat—the common fixer sodium thiosulfate degrades to produce cyanide gas. The amount of silver used for photographic purposes fell by some 50 percent between 1998 and 2007.

THE BIGGEST PHOTOGRAPH

A DISUSED AIRCRAFT hangar in Orange County, California, was transformed into a pinhole camera to produce the world's largest seamless conventional photograph, albeit a negative image. A quarter-inch hole in the door of the blacked-out hangar projected an image 32 feet (9.8 m) high × 111 feet (34 m) wide onto a roll of fabric primed with 20 gallons of light-sensitive emulsion. A 35-minute exposure was followed by development in a vinyl-lined tray, washing by fire-hoses and fixing with 1200 gallons of fixer.

In the digital field, a succession of aligning photographs can be "stitched" together by software, and then viewed by scrolling across a screen. Picture dimensions are expressed in pixels, and are therefore difficult to compare size for size with printed images. Record-breaking images weigh in at 80 gigapixels, the equivalent of 8,000 images from a typical consumer camera. Such a picture could measure around 14,000 pixels across—over 115 feet at a computer-screen resolution of 72 pixels per inch.

LOST IN SPACE

THE STANDARD HASSELBLAD 500 C was extensively used by NASA during the Project Mercury program in 1962–3, and continued through to Project Gemini. During Gemini 10 in 1966, astronaut Michael Collins accidentally let slip his camera during a space-walk, and it drifted into space. For the Apollo moon-landing program, the motorized 500 EL was adopted, with extensive modifications to the electrics and lubrication to allow its use in a high-oxygen environment within the spacecraft, and in the extremely variable temperatures and near-vacuum conditions outside.

In order to accurately measure objects photographed on the moon, a clear plate with a pattern of crosshairs was inserted just in front of the film plane. Neil Armstrong had the camera firmly strapped to his chest and had to use guesswork to frame the iconic images of Buzz Aldrin. A total of 12 Hasselblads were left on the moon's surface during the Apollo program—only the exposed film and magazines making the return trip.

FOOTOGRAPHIC CHEMISTRY

PRINTMAKERS USING the painstaking technique of bromoil transfer use powdered magnesium carbonate to absorb surplus ink from the print surface. This is most easily obtained in the form of athlete's foot powder.

IN PURSUIT OF THE ORDINARY

MARTIN PARR (b. 1952) is a celebrated English photographer who specializes in anthropological photography, especially of the British as they struggle and largely fail to come to terms with the 21st century. A lifelong enthusiasm for postcards, especially those produced by John Wilfrid Hinde, preeminent photographer of Butlins' holiday camps, is evidenced in his own work. He won the Erich Salomon photo-journalism prize in 2006 (*see p. 17*).

> "*Recently I did a picture—I've had this experience before—and I made rough prints of a number of them. There was something wrong in all of them. I felt I'd sort of missed it and I figured I'd go back. But there was one that was just totally peculiar. It was a terrible dodo of a picture. It looks to me a little as if the lady's husband took it. It's terribly head-on and sort of ugly and there's something terrific about it. I've gotten to like it better and better and now I'm secretly sort of nutty about it.*"
>
> DIANE ARBUS

CAT CAM

THIS ESSENTIAL ITEM WAS devised in 2007 by Jürgen Perthold, a German-American from South Carolina. Prototypes were tested on Mr. Lee, his own wandering cat, and comprised a keyring-sized VistaQuest battery-powered two-megapixel digital camera, with additional electronics devised by Mr. Perthold, and set to fire the shutter at intervals of between five seconds and eight hours. The production-standard device now weighs in at under 70 grams, can shoot short movies, and is available to buy at around US$50. Users can expect surprising results documenting their pets' adventures, but some cats have returned home without the easily detachable collar-mounted camera, a disadvantage it shares with the recently introduced video version.

I AM A CAMERA

CHRISTOPHER ISHERWOOD'S 1935 novel *Mr Norris Changes Trains*, and its sequel *Goodbye to Berlin* of 1939, inspired John van Druten's play *I am a Camera*, and the 1955 film of the same name. The observer-cum-narrator states, *"I am a camera with its shutter open, quite passive, recording, not thinking. Recording the man shaving at the window opposite and the woman in the kimono washing her hair. Some day all of this will have to be developed, carefully printed, fixed."*

ACRONYMS: B & C

BMP BITMAP: computer file format developed by Microsoft and IBM, still prevalent (unlike some other file formats, it is not patented) but now largely superseded by JPEG and PNG.

CCD CHARGE COUPLED DEVICE: the sensitive area or "sensor" at the heart of a digital camera. Light which falls on the sensor is translated into electrical charges by a microscopically fine grid of pixels.

UNDERCOVER OPERATOR

ERICH SALOMON BEGAN working for the Ullstein publishing group in 1925, and soon became fascinated by photography, especially by the possibilities of shooting at low light levels. His career was launched by his coverage of a sensational murder trial. Concealing his camera in a bowler hat, he recorded all the protagonists and, when challenged by a court attendant, yielded up only the unexposed film, escaping with the rest. He attended most of the European conferences of the interwar years. One affronted diplomat sighed, "One can hold conferences these days without ministers, but not without Dr. Salomon." The French Foreign Minister wondered, "Where is Dr. Salomon? We can't start without him. The people won't think this conference is important at all." Salomon preferred the Ermanox camera, with its large-aperture lens. He would hide it under his coat, and fire the shutter using a cable-release running up the inside of the sleeve.

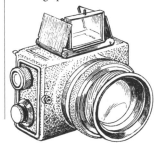

PRIZES

IF YOU HAVE taken a remarkable photograph, why not submit it for an award? Here are two competitions you can't enter:

DEUTSCHE BÖRSE PHOTOGRAPHY PRIZE. The Academy of The Photographers' Gallery in the UK nominates photographers with published or exhibited work. No application process.

THE HASSELBLAD FOUNDATION INTERNATIONAL AWARD IN PHOTOGRAPHY. The directors of the foundation select candidates in committee. A prize of 250,000 Swedish kronor, a gold medal, and a diploma. No application process.

And some you can:

TAYLOR WESSING PHOTOGRAPHIC PORTRAIT PRIZE. Administered by the National Portrait Gallery in London, with a prize in 2010 of £12,000, and a commission from *Elle* magazine.

VEOLIA ENVIRONNEMENT WILDLIFE PHOTOGRAPHER OF THE YEAR. Run by the London Natural History Museum and *BBC Wildlife* magazine. First prize: a trip to Borneo.

PRIX HSBC POUR LA PHOTOGRAPHIE (professionals only). Guaranteed production of a book featuring your work, an exhibition, and purchase of works for 5000 euros by HSBC.

TERRY O'NEILL AWARD. A first prize of £3000, and publication in *The Sunday Times Magazine.*

FUJIFILM STUDENT AWARDS. For photography and graphic design students only. Photographs to be taken on Fujifilm Pro. Prize: £200 of Fuji film, a trophy and a professionally printed portfolio.

SONY WORLD PHOTOGRAPHY AWARDS. Run by World Photography Organisation. Professional prize US$25,000—amateurs US$5,000.

INTERNATIONAL PHOTOGRAPHY AWARD. Professional prize: US$10,000 and a Lucie statuette; amateur and student prize US$5,000.

SYNGENTA PHOTO PRIZE. Photographs celebrating agriculture can win prizes of up to US$8,000 of Canon equipment.

DEUTSCHE FOTOGRAPHISCHE AKADEMIE (the German Photographic Academy). The David Octavius Hill Medal and 5,000 euros.

FOGDTAL FOTOGRAFPRISER. A prize of 250,000 Danish kroner. Entry only for Danish nationals.

ALL-ROUND DISASTER

THE NIMSLO 3D CAMERA was introduced in 1982, designed by Jerry Nims and Allen Lo. It featured four lenses side by side and used standard 35mm film. The Nimslo Corporation of Atlanta, Georgia, USA, retained the monopoly on processing the film, using a complex process to produce laminated, lenticular prints which combined the four viewpoints to produce a stereoscopic illusion. Forty-seven million US dollars of venture capital were injected into the company, of which 25 million were expended on the initial advertising budget, resulting in a loss for the year of 18 million. The processing department studiously refused to print any material they considered shocking, and would include a stern note to that effect in the returned order.

Part of the failed company was acquired by Nishika Ltd, who produced re-designed cameras using the same technology. In 1996, their involvement in a deceptive prize-promotion scheme resulted in an injunction from the US Federal Trade Commission. Second-hand cameras from Nimslo and Nishika now fuel a "retro" revival which is serviced by a number of companies offering versions of the original film-processing service.

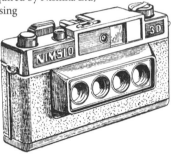

WAR AND SCANDAL

ERNEST BROOKS (b. 1878) was the first official British war photographer. His output represents ten percent of the Imperial War Museum's World War I archive. He was first commissioned as the official Admiralty photographer, then transferred to the War office. By 1920, he was official photographer to the Prince of Wales, but an undisclosed scandal ensued which resulted in his sacking and the cancellation of his military medals.

GOBO

THE VENETIAN BLIND PATTERNS beloved of *film noir* directors are produced by carefully cut masks, or "gobos," applied to the face of a light source. Irregularly shaped gobos, placed further from the source and sometimes called "kukaloris," produce dappled backgrounds.

—THE FATHER OF BRITISH PHOTOGRAPHY—

IN 1833, WILLIAM HENRY FOX TALBOT (1800–1877) was on a family holiday in the Italian Lakes. While others sketched, he was bored, being the only member of the party without artistic ability. The "camera lucida," a modified camera obscura designed to aid sketching, left him disappointed: "When the eye was removed from the prism—in which all had looked beautiful—I found that the faithless pencil had only left traces on the paper." Some time after returning to the family seat of Lacock Abbey in Wiltshire, UK, Fox Talbot began experimenting with paper soaked in silver nitrate and ordinary table salt. He succeeded in producing silhouettes of leaves and flowers by placing them on the treated paper in bright sunlight, though the images were fleeting until he managed to "fix" them using potassium iodide.

Strangely, Fox Talbot shelved these experiments, and was only prompted to recommence in 1839 by news from France of Daguerre's success, using a completely different technique. Positive "Daguerrotypes" were made directly in the camera: Fox Talbot's "Calotypes" used an intermediate negative to produce a positive print. This meant that multiple copies could be produced at speed, and encouraged Fox Talbot to launch into book publishing, using bound-in calotype prints along with an explanatory text. His book, *The Pencil of Nature*, was at first well received, but then became notorious as many of the handmade and haphazardly processed prints began to fade away.

His reputation suffered further with a series of court cases over the status of his photographic patents. In 1854 he was finally acknowledged, if only by the British, as the inventor of photography, but the patents were rendered valueless. However, all was not lost, the débâcle with the "Pencil of Nature" pictures propelled him into further experimentation, culminating in the invention of the photogravure printing process.

————— ACRONYMS: D —————

DFN DAY FOR NIGHT: shooting in daylight (usually in movies) with heavy filtration or extreme under-exposure in an attempt, generally unsuccessful, to simulate night-time or bright moonlight. Disparaged by the French as "la nuit Américaine" (American night).

DIN DEUTSCHE INDUSTRIE NORM: the German standard for describing film sensitivity, on a scale typically running in degrees from 10° to 30°.

DPI DOTS PER INCH: the number of individually discernible dots per inch in a printed photographic image.

> "I hate cameras. They interfere, they're always in the
> way. I wish: if I could just work with my eyes alone.
> To get a satisfactory print, one that contains all that
> you intended, is very often more difficult and danger-
> ous than the sitting itself. When I'm photographing,
> I immediately know when I've got the image I really
> want. But to get the image out of the camera and into
> the open, is another matter."
>
> RICHARD AVEDON

KUKALORIS

A FREE-STANDING PANEL placed in front of a light source. It has random
holes cut in it to produce patterned shadows in the background.

ACRONYMS: E

E-6: the Kodak patented development process originally for Ektachrome
color transparency film. It can also develop Fujichrome and related film.

ED EXTRA-LOW DISPERSION: denotes a superior glass used, especially in
telephoto lenses. It resists scratching better than conventional lens glass, but
has a lower index of refraction, so individual lens elements have to be more
curved to achieve the same effect.

EMR ELECTROMAGNETIC RADIATION: visible, photographable light is a
form of EMR, extending from 400 to 700 nanometers. Ultra-violet light exists
below 400 nanometers, and infrared above 700 (see p. 82).

EV EXPOSURE VALUE: a now obsolescent description of the total amount
of light reaching the film, with EV 0 denoting one second's exposure at a
theoretical aperture of $f1.0$.

SUN WORSHIPPING

SOLARGRAPHY APPEARS TO have been invented in Finland. It is a world-wide project to collect data about the sun's tracks across the earth. The equipment required for participation is as follows:

1. a can with a removable lid; 2. a sheet of black-and-white photographic paper; 3. black adhesive tape; 4. black spray paint (optional); 5. strong string.

Method: puncture the side of a regular metal food can using a drill. Spray the interior black and allow to dry. Tape over the hole. In darkness or darkroom safelight, curl a small sheet of photographic paper into the can, sensitive side facing the taped hole. Secure the lid with more tape and ensure it is light-tight. Choose a secure location facing south (north if you're in the southern hemisphere), make a pinprick in the taped-over hole and fix the can to its support.

Photographic paper is used rather than film because of its inherent lack of sensitivity. Exposures vary from a couple of days to six months, depending on the location and the diameter of the pinhole. No chemical development is necessary, and the image, bizarrely, is usually in color due to the lengthy degradation of the silver emulsion. Typical pictures, once they have been scanned to produce a positive, show the sun's passage as a series of bright arcs across the sky, with the immediate static environment recorded in soft focus. You are welcome to participate in the project by becoming a "can assistant." Details can be found at www.solargraphy.com.

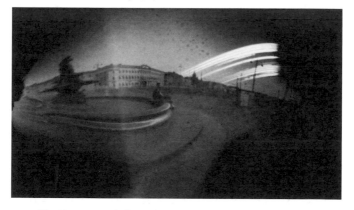

The Havis Amanda fountain in Helsinki captured by Tarja Trygg,
one of the founding fathers of Solargraphy. Exposure time: two months.
The reclining figure is a bronze sea-lion.

CHEESE

APART FROM THE well-worn English "watch the birdie," there are national variations in the words used to elicit a photogenic smile. Some have adopted the English "cheese" practice in a spirit of cultural irony. All have the same aim: a forced contraction of the muscles at the side of the mouth.

BULGARIAN: "zele" (cabbage)

BRAZILIAN PORTUGUESE: "x" (sounds like cheese)

CANTONESE CHINESE: "一 二 三" (one, two, three)

MANDARIN CHINESE: "茄子" (aubergine)

CZECH REPUBLIC: "sýr" (cheese)

DANISH: "appelsin" (orange)

ESTONIAN: "hernesupp" (pea soup)

FRENCH: "ouistiti" (marmoset monkey)

GERMAN: "spaghetti"

INDONESIAN: "buncis" (green beans)

KOREAN: "kimchi" (also cabbage, but pickled)

RUSSIAN: "сыр" (cheese)

CASTILIAN SPANISH: "patata" (potato)

CATALAN SPANISH: "Lluís" (proper name)

THAI: "pepsi"

ACRONYMS: F

F: THE LETTER ENGRAVED ON EVERY LENS: the accompanying numeral indicates the maximum available aperture (or f-stop), and is calculated as a ratio—the focal length of the lens in millimeters divided by the diameter (mm) of the lens aperture. Thus, a lens with a 50mm focal length and an aperture of 25mm gives an f-number of 2. The figures engraved on the lens run counter-intuitively from the largest aperture—$f2$ in this instance—to the smallest—$f22$, for example. The scale is logarithmic: $f2$; $f2.8$; $f4$; $f5.6$, and so on, but the key idea is that a smaller number means a bigger hole, more light getting into the lens, shallower depth of field (depth of focus, if you prefer), less good definition (probably), and allows a relatively faster shutter speed.

EDWARD CHAMBRÉ HARDMAN

THE UK'S NATIONAL TRUST looks after a number of locations in the Liverpool area, the most-visited being the childhood homes of John Lennon and Paul McCartney. However, the target for photographic enthusiasts is 59 Rodney Street, the carefully preserved former home, studio and darkroom of Edward Chambré Hardman. Born in Ireland in 1898, he initially set up a Liverpool studio in partnership with Kenneth Burrell, who he had met in the army.

In 1948, he moved to Rodney Street with his wife, Margaret, who had been one of his assistants during the period working with Burrell. Hardman was by now the pre-eminent Liverpool portrait photographer, but also found time to record the life of the city and the surrounding countryside. The studio prospered during the forties and fifties, with a strong demand for portraiture and industrial photography in Liverpool's docks and factories, using his favored camera, the Rolleiflex twin-lens reflex.

He retired in 1965, and the premises began a slow decline. His wife, Margaret, died in 1970, and by the mid-seventies Hardman himself was in poor health, requiring the help of the city's social services. They decided to clear the house of 50 years' accumulated "rubbish," but there was a fortuitous intervention by Liverpool gallery director Pete Hagerty, who persuaded Hardman to give the material, including 125,000 negatives, to a trust for preservation.

THE RAREST CAMERA OF ALL

ONLY ONE EXAMPLE is known to survive of one of the earliest commercially available cameras. Built by the Parisian firm of Susse Frères to the specifications of Louis Daguerre in 1839, it comprises two wooden boxes which slide into each other to focus the image, and a brass-mounted lens fitted with a swiveling cap. Once the image has been composed, the ground-glass focusing-screen at the back of the camera is replaced with a Daguerrotype plate. The lens cap is rotated for an exposure of anything from three to 30 minutes, followed by immediate development in mercury fumes. This apparently unique camera was sold at auction in 2007 for just over half a million UK pounds.

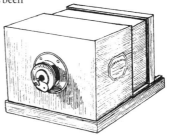

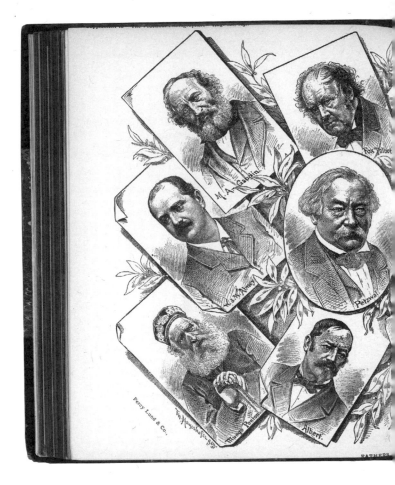

THE FATHERS OF PHOTOGRAPHY. Center: Joseph Petzval (*p. 75*), and Nicéphore Niépce (*p. 45*). Clockwise from top: Niépce de St Victor, cousin of the latter and inventor of heliogravure; Louis Daguerre (*p. 50*); Henry Peach Robinson (*p. 7*): Mathew Carey-Lea (*p. 64*); Louis-Alphonse Davanne and Louis-Alphonse Poitevin, both chemists, photographers and photo-engravers;

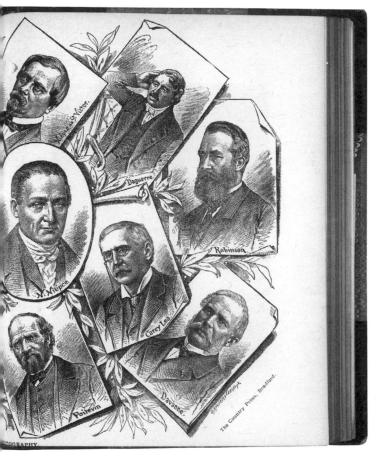

Courtesy of George Eastman House, International Museum of Photography and Film

Joseph Albert, photographer to Ludwig II of Bavaria; Mungo Ponton, pioneer of the gum bichromate process; William de Wiveleslie Abney, inventor of hydroquinone developer; Marc-Antoine Gaudin, daguerrotypist and, with his brother Alexis, pioneer of stereoscopic photography, and William Henry Fox Talbot (*p. 19*). From *The Practical Photographer,* August 1891.

DUST

A REMARKABLE AMOUNT OF dust pervades the universe, and a great deal of it has always landed on and around the photographer. Skin flakes, dog hair, sand, pollen, textile fibers and dust mites have a remarkable affinity with lenses, film drying in the darkroom rack, slides in the projector gate and, more recently, on the digital camera sensor. Old-style preventive measures in the darkroom involved meticulous negative storage, humidifiers, aerosol sprays, air and water filters, even the wearing of a surgeon's hat and gloves. For every particle missed by these measures there was a matching white spot on the final print in need of retouching with a fine brush charged with a tiny amount of spotting dye.

Digital cameras with interchangeable lenses attract dust because of the electrical charge in the sensor. Particles fall on the filter which sits immediately in front of the sensor itself, and even a tiny speck can record as a noticeable flaw on the final image. Early digital cameras, such as the Nikon D1, suffered badly from this problem, exacerbated by the "bellows" effect of most zoom lenses sucking in dust-laden air. The manufacturer's initial response was two-pronged: deny the problem, and blame the filthy habits of the photographers. Eventually they relented and offered an in-house cleaning service.

Successors to the D1 used software on the computer to process a "dust-off" reference photo made by shooting an unfocused frame of a clear white area, or of a cloudless sky. The result is an invisible file which records the position of all unaffected pixels in the sensor, a mask in graphic terms. The subsequent application of this mask to each image allows the software to clone surrounding pixels to cover the dust spots. The "dust-off" photo needs to be updated over time to take account of new dust. Alternatively, there are swab-and-liquid cleaners, and air-blast devices for home use by the confident. The filter in front of the sensor is extremely delicate and costly to replace. More recent cameras include automatic dust-removal mechanisms. Typically, on power-up, the filter screen is vibrated to dislodge any particles, and the first operation of the flip-up mirror blows a tiny current of air, and dust, out of the camera.

ACRONYMS: G

GSP GELATIN SILVER PRINT: marketing-speak for an ordinary print on black-and-white paper. In digital printing terms, the word "giclée" occupies similar shifting ground, denoting an inkjet print produced to fine-art standards, using superior machinery. It sounds French, and it is, but the literal translation is "forced through a nozzle," and in the native French is very much more likely to occur in references to procreation.

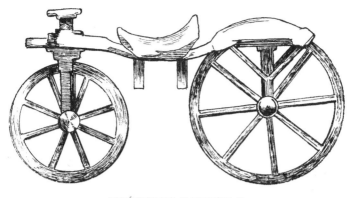

NIÉPCE'S BICYCLE

THE DESIGN OF THE modern bicycle owes much to Nicéphore Niépce, the inventor of photography. In 1819 he substantially improved Karl von Drais' rudimentary wooden *Laufmaschine* by adding handlebar steering and a saddle. Niépce named his version the *Vélocipède* (a Gallic reworking of the Latin *velox pedis* or fleet of foot), though the term was not adopted in France until 40 years later.

DIGITAL NEGATIVE FORMAT

THE POINT-AND-SHOOT digital camera usually produces a compressed JPEG file in order to allow the maximum number of images to be saved on a memory card. The JPEG format discards some of the information in the original scene, information which cannot be retrieved afterwards.

At the other end of the scale, professional cameras have for some time offered the Raw format, capable of recording a much greater amount of information at the moment of exposure, and facilitating subsequent computer manipulation of exposure and color temperature. However, each camera manufacturer promoted their own flavor of Raw, so that software manufacturers are obliged to provide fixes to convert the various versions. DNG, the Digital Negative format, published by Adobe, aims to sidestep the problem with a universal format, a move which seems to be attracting support from the camera makers. DNG is not to be confused with PNG (Portable Network Graphics), a flexible file format which was designed to replace the ancient GIF (Graphics Interchange Format).

MORSE AND BRADY

S AMUEL MORSE, INVENTOR OF the telegraph and co-inventor of Morse code, was instrumental in introducing photography to North America. While in Paris in 1839, he wrote to Louis Daguerre to request a meeting. Though the latter was waiting anxiously at the time for a government decision on a pension to reward him for donating the "Daguerrotype" patent to the nation, he agreed to meet Morse. The French government awarded the pension, and in an unprecedented gesture, gave away the process as "a gift, free to the world."

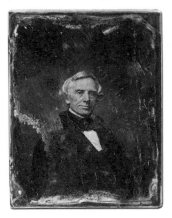

Daguerrotype of Samuel Morse made by Mathew Brady.

Back in New York, Morse became the earliest practitioner of the new process, and later initiated Mathew Brady, the author of a vast suite of photographs of the American Civil War. His rôle was principally in organizing other photographers under his control, and many of them worked anonymously, so after the war Brady was credited for many of the images. He had been a successful New York studio photographer, but had felt compelled to go to the battlefields in spite of the discouragement of his friends. His exhibition in the city entitled "The Dead of Antietam" horrified the public with its explicit images of mutilation and death. After the war, he was unable to reconstruct his career, and eventually died penniless in 1896. Morse had expired in much better circumstances in 1872, his contributions recognized by a bronze statue in Central Park, and a blue plaque on a house in Cleveland Street, London, where he had lived from 1812 to 1815 while studying painting at the Royal Academy.

> *"I never cared for fashion much, amusing little seams and witty little pleats: it was the girls I liked."*
> DAVID BAILEY

PAPARAZZI

THE CHINESE TERM for paparazzi is "dog team." The origin of the Italian term is disputed, but appears to have originated in Federico Fellini's 1960 film *La Dolce Vita*. One of the characters is a newspaper photographer called Paparazzo, and Fellini stated that the name came from an Italian dialect term for mosquito. Fellini's screenwriter at the time disagrees, and insists that it was just a name the filmmaker noticed in a book, and simply chose at random for the character.

THROUGH A GLASS, UPSIDE-DOWN

THE PRINCIPLE OF THE camera obscura was known in China in the fifth-century BC, and was described by the philosopher Mo-Ti. Two centuries later, Aristotle spoke of the crescent shape of a partially eclipsed sun appearing on the ground, focused through the holes in a sieve. The Persian polymath Ibn al-Haytham (b. *c.*965 AD) perfected a device capable of projecting an image of the outdoors onto an interior wall, though it was upside-down and reversed left-to-right.

Seventeenth-century improvements made the camera obscura portable, and artists were able to trace over a correctly oriented image, and in 1827 Nicéphore Niépce adapted the device to produce a "heliograph," the world's first photograph.

INTEGRATING TECHNOLOGIES

THE FIRST MOBILE PHONE to incorporate a camera was the J-SH04, made by Sharp and released, to the Japanese market only, in November 2000. Within the year, image-sending was incorporated into the text function. By 2003, the worldwide market had expanded to the point where sales of camera-equipped mobile phones overtook those of conventional digital cameras. The early camera-phones were rudimentary in photographic terms, and extremely expensive, but current models compete on almost level terms with consumer point-and-shoot cameras, now featuring high-resolution sensors, movie-making with editing on the fly, and in-camera special effects.

——IN THE BASEMENT, SOMETHING STIRS——

THE HOLGA CAMERA provides a refuge for photographers overly pre-occupied with, and probably exhausted by, the demands of high-precision digital photography. It is made of plastic and equipped with a simple meniscus lens, also made of plastic. The original model uses 120 film, has adjustable focusing, fixed shutter speed and a choice of two apertures. Pictures taken on either aperture setting show the same result, since, due to a manufacturing oversight, the aperture linkage was omitted. Additionally, the 120 format (6 × 6 cm square) led to severe vignetting caused by inadequate lens coverage. However, a switch is provided to reduce the format to 6 × 4.5 cm, thus solving the problem. The ill-fitting body components,

however, together with the inadequacy of the soft-focus lens, mean that almost all photographs exhibit lens flare, ghosting, chromatic aberration or fogging. Accidental multiple exposures are common. Fortunately, these features have been retained in the recently introduced stereo version: qualities that have made the Holga method so desirable, the ideal instrument with which to push back the boundaries of photography.

"Best wide-angle lens? Two steps backward."

ERNST HAAS

——————ACRONYMS: H——————

HDR HIGH DYNAMIC RANGE: using several (usually three) shots taken at the same time, with bracketed exposures, typically one stop over-exposed, normal, and one stop under-exposed, it's possible to produce a merged image in the computer. Since the human eye can distinguish a much wider range of tonal values than film, the result looks more "real." The effect is especially marked in pictures including cloudscapes which might otherwise appear too light or "blown out." With more aggressive manipulation of the software controls, the merged image takes on a surreal appearance.

———— CURIOUS HABITS IN THE STUDIO ————

IN THE DIFFICULT TRADE of food-and-drink photography, things are not always, or ever, what they seem. It is well known that ice-cubes are made of glass or plastic (top-quality cubes cost around US$30 a piece) and what looks like ice-cream is probably lard or mashed potato. Both products melt at room temperature, and won't sit quietly while the food stylist strives for perfection. But how to get the right level of soup in the bowl without splashing it all over the set? Flat seaside pebbles do the job, slid carefully into the liquid to make the level rise and, incidentally, to produce a generous-looking convex meniscus. How to prevent the crunchy breakfast cereal subsiding soggily into the milk? Forget the milk and use white PVA wood glue. Steam? Microwaved water-soaked cotton-wool balls. Shiny fruit? Glycerine. Well-done beef? Blowtorch. However, many food photographers now profess to have cleaned up their techniques so rigorously that they will now happily eat the set at the end of the day. Bon appetit.

———— IN SEARCH OF THE THIRD DIMENSION ————

DENNIS GABOR established the principles of holography in 1947, but the process became a much more practical proposition in the 1960s with the introduction of the laser. Gabor received the Nobel prize for Physics in 1971, by which time two variants had become established. Both depend on the original concept of one beam of light being split into two, one illuminating the subject and the other being diverted by mirrors onto the recording medium.

The first beam scatters light onto the same recording medium, and the fractional differences between the two beams record the three-dimensional shape of the subject. The light source, subject, mirrors and recording medium need to be solidly anchored to eliminate the minutest vibration. Any disturbance at these critical wavelengths renders the hologram unusable. "Transmission" holograms depend on laser light being passed through the hologram to form the 3D image, while the "rainbow transmission" hologram uses white light to activate the image.

The metalized security devices on credit cards are of this type, with a reflective backing to increase the amount of light passing through. A more recent development is the "reflection" hologram which can record in color. However, subjects are limited to the very static, though a Japanese institute has demonstrated a system capable of recording moving subjects. However, the finished size of the hologram is currently unacceptably small. The same institute also proposes holographic television by 2016.

THE WPA

THE US WORKS PROGRESS ADMINISTRATION (part of the "New Deal"), was established in 1935 as a government response to widespread unemployment. A budget of almost five billion dollars was targeted at public works projects, and although the great bulk of the newly active workforce were involved in construction and renovation, there were also opportunities for artists and photographers under the umbrella of the Federal Art Project.

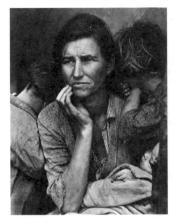

Migrant mother and child.
DOROTHEA LANGE

Berenice Abbott, for example, gained a commission to photograph New York City. She had been a photographer since the early 1920s, working first as a darkroom assistant to Man Ray in Paris, and subsequently opening her own gallery. After achieving success as a portrait photographer, she returned to New York in 1929, and began documenting the city's buildings with an 8 × 10 inch plate camera. She struggled to make a living in the early 1930s until the WPA opportunity materialized. Other photographers commissioned included Walker Evans, notable for his implacable opposition to the aims of the WPA, Dorothea Lange, already known for her pictures of migrant families in the Depression, and Eudora Welty, otherwise known as the author of *Death of a Traveling Salesman*.

ACRONYMS: I

IS IMAGE STABILIZATION: denotes various systems for mechanically stabilizing the image to mitigate the effects of camera-shake. Some are part of the lens itself, detecting movement and counteracting it by shifting lens elements with miniature electric motors. Others move the camera sensor itself to achieve a similar result.

ISO INTERNATIONAL ORGANIZATION FOR STANDARDIZATION: in the photographic context, ISO is a measure of film speed, typically in the range 25–1200.

THE HAND OF LUMIÈRE

IN 1916, WITH THOUSANDS of mutilated soldiers returning from the trenches, Louis Lumière, co-inventor of cinematography with his brother Auguste, designed a prosthetic hand to assist in their rehabilitation. Auguste contributed also with the invention of "tulle gras," a bandage impregnated with paraffin jelly, which was used in the treatment of burns and infected wounds.

However, Louis was the more prolific, in terms of sheer numbers of patents applied for. These include: the "périphote" for filming and subsequently projecting 360° panoramas; a stereoscopic imaging system for pathological research; a paper diaphragm to replace the metal trumpet on early phonographs; antiseptic soap; a catalytic heater to prevent freezing of aircraft fuel, and a novel form of automobile rear light.

A FINE BALANCE

THE INTERNATIONAL COLOR CONSORTIUM says, "the purpose of the ICC is to promote the use of open, vendor-neutral, cross-platform color management systems." The intention is to achieve a printed image which resembles as closely as possible the one seen on the monitor. The system depends on a set of profiles, calibrated to account for color anomalies at each stage of the print (or photographic) workflow. So, the computer monitor will have its own ICC profile, as will the scanner and camera, the inkjet printer, color proofer and, ultimately, the commercial printer's output devices at the end of the workflow.

MAGNUM FORCE

THE MAGNUM photographic agency was founded soon after World War II by four photographers: the Hungarian, Robert Capa, already known for his pictures of the Spanish Civil War; Henri Cartier-Bresson (*see p. 89*), who had been a prisoner of war for three years, escaped and joined the Resistance; George Rodger, a British photo-journalist who worked extensively in Africa, and subsquently photographed the Bergen-Belsen concentration camps, and David Seymour (alias "Chim" for his original Polish surname, Szymin) who had also worked during the Spanish Civil War and later photographed European refugee children. Magnum has expanded over more than 60 years, and still dominates the photo-journalistic world. The work of 81 photographers is now promoted by the agency, including that of its four late founders.

MAPPLETHORPE

ROBERT MAPPLETHORPE (b. 1946) studied at the Pratt Institute in Brooklyn but dropped out before finishing his graphic arts course. Finding photography a more sympathetic medium, he started making Polaroids in the early 1970s, using a circle of friends as subjects. By the middle of the decade, he was using a Hasselblad and concentrating on studio-based photgraphy. His notoriety was established at this period with suites of pictures of sado-masochistic activity, and clashes with religious organizations objecting to publicly funded exhibitions of his work. Mapplethorpe contracted AIDS and died from complications in Boston in 1989. The Mapplethorpe Foundation promotes his archive and directs funds to AIDS research.

ACRONYMS: J

JPEG THE JOINT PHOTOGRAPHIC EXPERTS GROUP: the history of JPEG (sometimes "JPG") stretches back to the time when computers were only capable of displaying text and crude graphics. An ISO committee had started work in 1983 to establish a standard for the display of photographs on computer monitors. The problem then, as now, was that photographs translate into large data files: JPEG reduces file sizes by analyzing the image for redundancy and repetition (the thousands of similiar pixels in an area of sky, for example) and approximates them. Some information is lost, but the eye is deceived, unless the compression ratio is extreme.

"It is a peculiar part of the good photographer's adventure to know where luck is most likely to lie in the stream, to hook it, and to bring it in without unfair play and without too much subduing it."

JAMES RUFUS AGEE

ECLIPSED

THE SAFEST WAY OF photographing a total or partial solar eclipse is to use an indirect method. A sheet of thin card with a pinhole can be used to project the image onto a similarly sized sheet of card secured perpendicular to the sun's rays. During a total eclipse, the sun's bright ring (the corona) will be clearly visible by projection onto a flat surface, and can be safely photographed using a conventional camera. Direct use of the camera involves the use of a specific solar filter, NOT a stack of polarizers, neutral-density filters or welder's glasses. Preparation is paramount, since the shadow of the moon arrives at around 1,700 km/h, but there is plenty of time to get ready: though in a year there are up to five eclipses of all kinds, the shadow is only ever cast in a 300 km-wide band on the Earth. A total eclipse is (or was) expected over Australia and the Southern Pacific in November 2012.

SURREPTITIOUS

THE STIRN CONCEALED VEST Camera was equipped with a circular glass plate allowing for six exposures to be made, with a lens designed to protrude discreetly through a buttonhole. The shutter was fired by tugging on a piece of string attached to a short length of chain. The instruction book advises that the operating hand should be concealed in a trouser pocket. Stirn went on to produce a miniaturized 360° panoramic camera called "The Wonder."

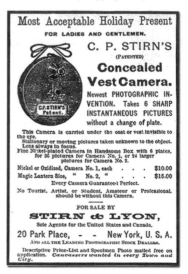

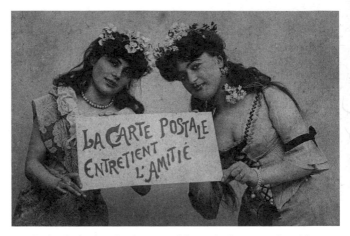

They're absolutely right, the postcard does indeed maintain friendships.

SILICON FILM

SILICON FILM TECHNOLOGIES INC showed the prototype of their "EFS" digital film cassette at the 2001 Photo Marketing Association exhibition. It had been developed for photographers wanting to continue using their film cameras in the face of the increasing uptake of digital imaging. In the EFS system, the space in a conventional camera normally occupied by a 35mm cassette contained the "eFilm" cartridge of electronics, while the attached "flag," incorporating a CMOS sensor, slotted into the film plane. No camera modification was needed, and after 100 exposures, the device would be slid into a dock enabling download to a computer. The then small size of available sensors meant that the exposed area was only 35 percent of the conventional 35mm film frame (it should be noted that Nikon, for example, still market their DX format which offers around 43 percent equivalent coverage). The prototype failed to make it into production after failing US and European standards tests, and the program was finally abandoned with significant losses in September 2001. However, the parent company is still active in the optical sensor and pilotless surveillance drone business.

CRISP DEFINITION

AUGUSTE AND LOUIS LUMIÈRE patented the Autochrome system in 1903 and commercialized it four years later. Soon, their factory in the Monplaisir suburb of Lyon was producing a million Autochrome plates a year. The basis of the process is a thin layer of potato flour granules, colored using three different dyes: reddish-orange, green, and violet-blue. It is vital that the finished coating is only one grain thick: the grains of potato flour are betwen 10 and 15 microns in diameter, a quarter the diameter of a human hair.

The glass plate was first lightly coated with a varnish of pitch with beeswax, the dyed grains dusted on to ensure an even distribution, then a layer of lamp black was rolled all over under pressure. The lamp black served to fill up the gaps between the grains of flour. The process concluded with a layer of conventional black-and-white emulsion, and a finishing coat of varnish. After exposure in the camera with the plain glass side facing the lens, the silver emulsion was reversal-processed to make a positive image.

The image is formed as follows: green light, for example, passing through a green-dyed grain would strike the emulsion in the rearmost layer, and eventually produce a clear dot. When viewed against a white light source, the dot will glow green. Red light would have no effect on this grain, but will activate a neighbouring grain, or grains, sensitive to red. The same follows across millions of grains for all the colors of visible light. Because of the microscopic grain size, the eye combines adjacent grains to reproduce the original colors.

In 1909, a French banker, Albert Kahn, commissioned a team of photographers to travel the world using the new system. By the time the project was finished in 1931, they had exposed over 70,000 plates, now on display at the Albert Kahn Museum in Paris. The dyes used in the Autochrome process were very permanent, so that exposures made in the early years of the 19th century remain brilliantly colored, but the system was doomed with the introduction of film-based products like Kodachrome in the mid-1930s. The last version of Autochromet, Alticolor, was discontinued in 1955.

FLASH, BANG, WALLET

THE FIRST GENERATION of film-based speed (or safety) cameras is being replaced in many jurisdictions by digital devices which dispense with the conventional electronic flash in favor of infrared. The addition of number-plate recognition facilitates average speed calculation by recording the recognized vehicle as it passes two or more cameras. All these models are likely to be rendered obsolete by laser-, radar- or satellite-based arrangements linked to a central database.

AIRBRUSHED

PHOTOGRAPHY IS A POWERFUL tool of propaganda, and the ability to manipulate it makes it even more so. Nikolai Yezhov was one of the architects of Stalin's 1937–8 Great Purge, but fell foul of Beria, his deputy, and was sidelined, disgraced, and finally shot in February 1940.

GEORGE EASTMAN

THE FOUNDER OF THE Eastman Kodak company was born in 1854 in Waterville, New York. He worked at various posts in the insurance business, and at the age of 24 acquired a complete photographic kit for a planned vacation and took a five-dollar course to learn how to use it. The vacation never took place, instead Eastman became absolutely fascinated by the equipment and equally frustrated by the complexity involved in coating the glass plates and exposing them before they dried out. He devised a system of coating a revised liquid emulsion onto glass plates so that they could be exposed when already dry.

With a view to establishing a business supplying commercial photographers with the new plates, Eastman opened a factory, but faced resistance from the wet-collodion old guard. At this point he effectively invented the consumer photographic market by making a paper-based film which could be rolled up and exposed in a simple "box" camera. In 1888 he introduced the pre-loaded "Kodak" camera with the slogan, "You press the button, we do the rest." After making 100 exposures, the customer returned the whole camera to the Eastman company: the return package included prints and a reloaded camera.

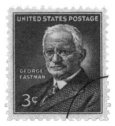

ACRONYMS: K

K KELVIN: the capital letter K following a numeral denotes the color temperature of a given light source. The scale was devised by the first Baron Kelvin, William Thomson, in 1848. In photography, the useful part of the scale runs from 1,700K to 6,500K:

1,700K	match flame	4,100K	moonlight
1,850K	sunrise/sunset	5,000K	daylight at horizon
2,700–3,300K	incandescent lamp	5,500–6,000K	electronic flash
3,400K	studio photoflood	6,500K	daylight, overcast

Low numbers describe a reddish-yellow light, high numbers tend toward blue. Film-photography filters correct these souces to a neutral white, 5,000K, more or less, and the same principle operates in color-correction software.

K KILOBYTE: the lower-case letter k following a numeral denotes so many kilobytes (1 kilobyte = 1,000 bytes, the smallest measure of space) of computer memory or storage space. One thousand kilobytes = 1 megabyte (Mb). This book, for example, occupies 22 Mb of disk space, or 22,000,000 bytes.

HIGH FLYING

GASPAR-FELIX TOURNACHON (under the pseudonym of Nadar) took the first documented aerial photograph from a tethered balloon over Petit-Bicêtre in the southwest suburbs of Paris in 1858. This image is lost, but Nadar persisted until becoming convinced, with the failure of his balloon *le Géant*, that heavier-than-air machines were the way forward. His compatriot Arthur Batut stayed on the ground and used a kite-camera with a timer fuse. The technique was later used by the surveyors of the route of the Trans-Siberian Railway.

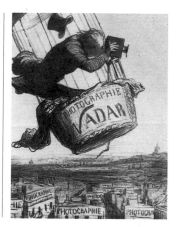

F. Hatherill
475, SOUTHWARK
PARK Rᴰ S.E.

THE CABINET CARD

FROM THE 1860S ONWARD, the large-format cabinet card replaced the smaller carte-de-visite: at around 4" × 6" (10 × 15 cm), it could be appreciated from across a crowded Victorian drawing-room. The traditions of romantic painterly portraiture are still in evidence, and celebrated by the elaborate reverse side of this card (*opposite*). The generous dimensions of the glass plate meant that any accessories and background flourishes that could not be arranged in the studio could easily be added on the negative with brush or pen. This might also be the moment to improve the sitter's appearance. By the end of the 19th century, the cabinet card itself was in decline following the introduction of the first Kodak camera.

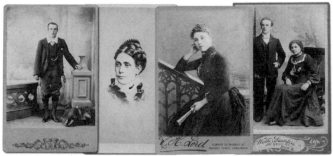

ACRONYMS: L

LAB, MORE PROPERLY L*A*B*: a color space devised by the International Commission on Illumination. It has three axes: a vertical l* axis for luminance, and two horizontal color axes at 90° to each other, a* and b*. The first runs from red to green, and the second from blue to yellow.

SEEING DOUBLE

THE ORIGINAL VIEW-MASTER stereoscopic viewer was introduced at the 1939 New York World's Fair. The device was designed by William Gruber, a keen photographer, and Harold Graves of Sawyer's, a long-established postcard manufacturer. It follows conventional binocular stereoscope practice, but with the sophistication of a lever-operated advance mechanism to view each of the 7-stereo pairs in sequence. The 14 photographs, duplicated on Kodak color ciné film, were sandwiched between notched cardboard discs.

In World War II, the US military commissioned discs to help train servicemen in recognition of their own and enemy ships and aircraft, though the main business remained the supply of discs showing exotic locations. The View-Master Personal Camera followed in 1952. It used 35mm color transparency film, and, taking advantage of the small picture format, doubled the number of exposures by displacing the lenses at the end of the roll to expose another row of shots along the lower edge of the film. The user had to mount his own pictures in the discs provided, and this delicate operation probably contributed to the camera's demise ten years later. View-Master was sold on several times in the 1980s, and is now part of the Fisher-Price toy empire. Ready-made discs are still available, but only of Buzz Lightyear and his fellow Disney-Pixar characters.

Take your own stereo PICTURES!

VIEW-MASTER *Personal* STEREO CAMERA

CHRONOPHOTOGRAPHY

ÉTIENNE-JULES MAREY invented the first camera for analyzing movement, and competes with the Lumière brothers to be acknowledged as the father of cinematography. He researched human circulation and then became interested in animal movement, especially the flight of birds and insects. His chronophotographic gun was made in 1882, four years after Muybridge had set up his multiple-camera rig to photograph a galloping horse. Marey's gun, however, used a different principle: all the exposures were made on the same plate, at the rate of 12 a second. He also photographed larger animals, up to and including an elephant, as well as recording the movements of shellfish and reptiles.

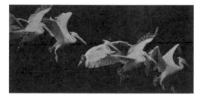

This pelican is flying freely, but Marey also strapped birds to a rotating arm in the studio. A miniature version of the same rig served for insect flight.

CURIOUS IMAGING PROCESSES

IF YOU FEEL THAT the fruit on your apple tree lacks that special something, try cutting your initials or some device out of black paper and pasting them on the developing fruit. You'll be rewarded with a personalized image—a lighter shadow on the ripening skin—and will never settle for blank apples again. Also works well with peaches and other soft fruit. More sinister is a tale re-told by the *British Journal of Photography*: in 1812, a Mr. Shaw announced that, "six sheep standing in an open pasture surrounded by woods were killed by lightning. The surrounding landscape was pictured so clearly on the inner surface of each skin that the view was immediately recognizable by those who were acquainted with the district." And then there is the case described by Dr. Conyers. While performing an autopsy on a gentleman who had died "for love" he discovered on the deceased's heart the clear imprint of the face of his reluctant inamorata. You couldn't make it up.

——————— PHOTOGRAPHS IN THE MOVIES ———————

BLOW-UP (1966) *dir. Michelangelo Antonioni.* Thomas (David Hemmings) is a successful fashion photographer, thoroughly enmeshed in "swinging London," who wanders into a park, and photographs a couple in the distance. In the resulting prints he sees a body lying in the bushes, and progressively enlarges the negative to discover the truth...

BEFORE SUNRISE (1995) *dir. Richard Linklater.* Céline (Julie Delpy) and Jesse (Ethan Hawke) meet by chance on a train. A relationship develops, and at one point Jesse stares intently at Céline and asks if he can take her picture. He has no camera...

THE MAN IN THE LOWER-LEFT HAND CORNER OF THE PHOTOGRAPH (1999) *dir. Robert Morgan.* An animated short film about a man in a decaying room, looking at an old photograph of himself and trying to recreate his youth...

MEMENTO (2000) *dir. Christopher Nolan.* Insurance investigator Leonard Shelby (Guy Pearce) loses his short-term memory after witnessing the murder of his wife by two assailants. He may have killed one of the attackers himself, but can only keep track by tattooing himself and taking Polaroid photos to help in the quest for the second murderer. The film unfolds chronologically in black and white, and simultaneously backwards in color...

ONE HOUR PHOTO (2002) *dir. Mark Romanek.* Photo-store technician Sy Parrish (Robin Williams, who got the rôle when Jack Nicholson turned it down) is obsessed by a local family, and secretly makes an extra set of prints every time they bring in a film. There are knowing photographic references throughout: a character named after Aaron Siskind, the abstract expressionist photographer, and an hotel called Edgerton after the pioneer of high-speed photography. When the family begins to break up, Sy decides to get involved...

> *"A revengeful God has given ear to the prayers of this multitude.*
> *Daguerre was his Messiah. And now the faithful says to himself:*
> *'Since photography gives us every guarantee of exactitude that we*
> *could desire (they really believe that, the mad fools!), then*
> *photography and art are the same thing.'"*
>
> CHARLES BAUDELAIRE

IN THE FIELD

THE PLATE OR "FIELD" camera of the 19th century still flourishes, but is no longer confined to the studio. Original whole- and half-plate cameras (6½" × 8½", and 4¾" × 6½", respectively) are still usable, but now shooting on film, rather than glass. More common are, in ascending order of popularity, 8" × 10", 5" × 7", and 5" × 4". In the latter format, old Graflex and Linhof Technika cameras are still an option. Newly made Japanese, and now Chinese, versions are out in force in the landscape, especially in the USA, and known as "view" cameras. They are designed to fold completely flat, are of lightweight construction and use the same hardwood and brass construction as their ancestors. Rising/falling lens panels are standard; some can also be shifted laterally, allowing the image to be moved within the film frame. The vertical movements allow correction of converging verticals in architectural photography. The lens panel and film plane can also be tilted, so that the plane of focus need not necessarily be perpendicular, as in a normal camera. This is especially useful in landscape photography, bringing near and far objects into the same plane of focus. Similarly, either the lens panel or film plane, or both, can be swung about their vertical axis to achieve even focus on a subject such as a building which may be at an angle to the camera.

ACRONYMS: M

M: (obsolete) shutter-speed setting for synchronization with a flash bulb.

MOB MOTHER OF THE BRIDE: wedding photographers' shorthand term.

MP MEGAPIXEL: one million pixels, used as a unit of measure to describe the resolving power of a camera sensor, as well as the number of pixels in the resulting image. In practical terms, each pixel in a sensor is only sensitive to red, green, or blue light, so that the effective "pixel count" is actually one third of that described. Advertising implies more MPs mean a better camera, and an enhanced ability to produce enormous, pin-sharp images, but camera stability and a sharply focused subject are much more significant. Logic decrees that if you *can* make a much larger print, you will inevitably view it from a greater distance, effectively wasting expensive pixels.

MTF MODULATION TRANSFER FUNCTION: a measure of a lens's ability to deliver high contrast and resolution, usually presented as lines describing both attributes on a graph. Values nearer to 1, the maximum possible, and flatter lines, denote superior lenses.

HANDY TIP

DEEP IN THE WILDERNESS in the late afternoon with a field camera (*see previous page*) on your back, a glorious photo opportunity in perfect golden light just over the next ridge? Whether to forge ahead while the light lasts to secure that shot, or to return to base before sunset? Stretch out an arm, raise a hand with the palm toward you and fingers parallel to the horizon. Align the side of your little finger with the skyline, and see how many fingers fit between it and the sun. Each finger means 15 minutes more light. An eminent cameraman cautions: err on the safe side, ten minutes per finger may be more appropriate, fewer if you have large fingers; the method only works in higher latitudes—near the equator, the sun sets too quickly for measuring.

IN THE ROUND

THE ARCHETYPAL SCHOOL photograph camera was the Cirkut, made by Kodak from the early 1900s until 1949. The system comprises a stand camera mounted on a rotating tripod head. The lens is fixed, but the film, which may be up to 16" (40 cm) long, is pulled past a vertical-slit shutter while the camera rotates to scan the scene. A system of clockwork-powered gears ensures that the two movements are synchronized—any hiccups in the mechanism result in vertical banding in the negative. Exposure is adjusted by altering the width of the slit in the shutter. The subjects, a 1933 Somerset school group in the example below, are arranged in an arc, equidistant from the camera. The lengthy traverse of the camera offers an athletic and inventive pupil the opportunity to appear twice, at either end of the photograph, the admiration of his fellows, and an even chance of expulsion. Such adventures are now rarely available: the Seitz panoramic camera, for example, takes just one second to scan the scene (*see p. 62*).

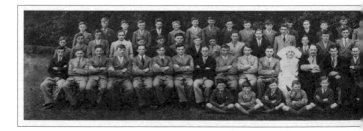

IS IT ART?

"BROWSING THROUGH THE stacks of the New York Public Library where books on the general subject of transportation were shelved, I came across the book by Ed Ruscha entitled *Twentysix Gasoline Stations*, a work first published in 1963 and consisting of just that: [photographs of] 26 gasoline stations. I remember thinking how funny it was that the book had been miscataloged and placed alongside books about automobiles, highways, and so forth. I knew, as the librarians evidently did not, that Ruscha's book was a work of art and therefore belonged in the art division. But now, because of the considerations of postmodernism, I've changed my mind; I now know that Ed Ruscha's books make no sense in relation to the categories of art according to which art books are cataloged in the library, and that that is part of their achievement. The fact that there is nowhere in the present system of classification a place for *Twentysix Gasoline Stations* is an index of its radicalism with respect to established modes of thought."

DOUGLAS CRIMP
Professor of Art History at the University of Rochester, NY.

REAR VISION

IRAQ-BORN ARTIST Wafaa Bilal has had a titanium disc implanted on the back of his head by a tattooist. His project, *3rd I,* begun in December 2010, is to transmit pictures to the internet via a web camera magnetically attached to the disc. A Qatari museum commissioned the project, one year in duration, with one picture being transmitted every minute. Bilal's students at New York University cried invasion of privacy, so he agreed to use a lens cap while at work. In a previous project, *Shoot an Iraqi,* he acted as a human paintball target, the gun being directed by visitors to his web site.

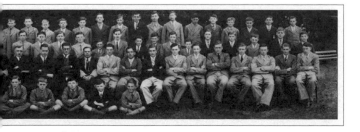

WHERE WAS I?

GEOTAGGING ENABLES the photographer to record location information for each image. A few cameras have built-in GPS functions which note positions automatically. At the time of writing, however, most systems depend on a secondary device, synchronized for date and time, and carried along in the camera bag. A GPS-equipped mobile phone can also do the job. The secondary device uses GPS to record the location of the camera against a time plot, and periodically uploads the log of information to a dedicated web site. When the photographs are transferred to a computer, a program adds location information to each picture using the log. A large collection of photographs can eventually be browsed for images taken at or near the same location.

FRANKE & HEIDECKE

THE TWIN-LENS REFLEX camera had been in existence for over 50 years by the time Reinhold Heidecke and Paul Franke brought the first Rolleiflex to market in 1928. Their contribution lay in the use of roll-film instead of a film- or plate-holder, a much-improved and brighter viewing system, and a compact design in which the chambers behind the viewing and taking lenses are cleverly dovetailed. Heidecke allegedly became convinced of the virtues of the TLR design while sheltering from sniper fire in the WWI trenches. He

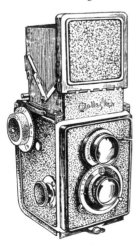

surmised that an upside-down TLR on the end of a broomstick would be a safer tool of reconnaissance than a telescope.

In 1966, Rollei introduced the SL66, a 6 × 6 cm format single-lens reflex, in direct competition with Hassleblad. It was discontinued in 1992. The Rollei TLR line, however, has developed up to the present day. The current model is a costly item for the collectors' market, though the principal business is in point-and-shoot cameras. The company itself has been re-born many times: owners have included a German bank, a British armored-vehicle manufacturer, the Samsung Corporation of South Korea, and a Danish investment company. Now, the Rollei camera-making business is again called Franke & Heidecke, with some descendants of the founders among the shareholders.

WATCH THE BIRD

THE BATTERY-POWERED bird cam is designed to be strapped to a tree, facing a branch or feeding-table, or simply left on the ground with some bird food scattered around. It uses an infrared sensor to detect movement, and can be set to take a burst of pictures when activated, then wait for the next event. A video mode is also available, and the more advanced model has electronic flash and time-lapse features. The same company also makes ProjectCam, another time-lapse device, destined for the shed, workshop or project room, where its unblinking eye should encourage industry over sloth.

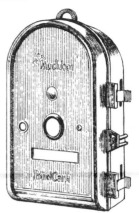

> *Stranger: "That is a beautiful child you have there."*
> *Mother: "That's nothing. You should see his photograph."*
>
> ANON

ACRONYMS: N

ND NEUTRAL DENSITY FILTER: a dark-gray filter, available in different densities, which vastly reduces light transmission to the camera when long exposures are required. The classic long-exposure waterfall photograph, in which the flow of water takes on the appearance of stone, is a product of the ND filter.

NEF NIKON ELECTRONIC FILE: Nikon's proprietary Raw file format. Canon's equivalent was CRW, now overtaken by CR2.

NIC(A)D, NIMH NICKEL-CADMIUM, NICKEL METAL HYDRIDE: the former is a long-established rechargeable battery type, used in cameras and flashguns. It is capable of delivering relatively high amperage compared with the NiMH type, but has a worse power-to-weight ratio and is more expensive. NiMH has been favored in modern cameras for its ability to deliver a small current over a very long period, but now has to compete with Lithium-ion (L-ion) batteries which are physically smaller, more efficient, but have issues regarding premature aging.

——————— FACIAL CHARACTERISTICS ———————

MANY POINT-AND-SHOOT cameras can distinguish a face in the view-finder, and the most recent generation can also recognize a particular face once instructed. This feature can be used in a digital album to call up all occurrences of that face, or all occurrences of the first face and another recognized face in the same frame. Both systems depend on a series of shape algorithms which are rapidly deployed when the camera-shutter button is pressed halfway. The basic camera is programed to look for oval objects with symmetrical marks in the upper half, a discontinuity in the middle, and a more or less straight mark in the lower half. In most cases, this will be a face, and the camera settings will be adjusted to get the best focus and exposure for that area. An averaging calculation is made when several faces are detected. As you might expect, the system doesn't work when the camera is held upside-down. Cameras with a smile-detection device can be set to delay an exposure until the subject obliges with a clear smile and open eyes, sometimes sounding an alarm if blinking is detected.

——————— IODINE AND MERCURY ———————

LOUIS DAGUERRE STARTED out as an architect, but soon preferred stage design. He devised and ran an enterprise in Paris called *Diorama* at which large theatrical cloths painted with exotic scenes were progressively revealed, all illuminated with changing light effects.

His connection with the infant photographic process was the camera obscura which he used to help in painting perspectives. He discovered the work of Niépce and formed a partnership with him in 1829, but the latter died in 1833, and another two years elapsed before Daguerre had perfected a superior method of obtaining and securing the photographic image. He used silver-plated copper plates, sensitized by iodine fumes, then given a lengthy exposure (this "posing-stand" was used for portraiture) and developed in mercury fumes. After this highly toxic treatment, the image was fixed in a salt bath.

Two difficulties always dogged the Daguerreotype process. First, the final image was reversed mirror-fashion, though this was not a great problem for the sitter, who had only ever seen her- or himself in exactly that way. Second, no further copies could be had from the initial exposure.

ACRONYMS: O

OOG OUT OF GAMUT: a color which, though it can be seen on a computer monitor, being included within the color gamut, or range, of that monitor, cannot be accurately reproduced in print or other media. For example, the intense red of an RGB monitor is "out of gamut" in a normal inkjet printer. See page 33 for an explanation of the ICC approach to color matching using a profile system.

OPD OBNOXIOUS PERSONALITY DISORDER: unattractive trait sometimes apparent in fashion photographers.

READY IN THE MORNING

THE FOTOMAT FRANCHISE WAS established in California in 1965, offering same-day film processing. By 1980 there were around 4,000 of the characteristic "thatched roof" kiosks, mostly in supermarket parking lots, but the business was torpedoed by the rise of "one-hour" processing. In 1979, a video rental service was introduced, but that proposition proved uneconomic in the face of relentless competition and was defunct by 1982. When the kiosk service was finally withdrawn, an online print service was introduced. This ended in 2009, when customers were redirected to a similar service provided by Kodak.

ON THE USES OF MOD PODGE

THIS GLUE-LIKE PRODUCT is available in several varieties, including Sparkle and Dimensional Magic, but the most useful for fooling around with transferring photographic images from one surface to another is the regular sort, matt or gloss. It works best with a high-contrast image printed by inkjet on ordinary photo-grade paper. First prepare the receiving surface by coating it with a thin layer of acrylic paint or varnish, and allow it to dry thoroughly. Coat the face of the inkjet print evenly with Mod Podge and stick it to the receiving surface.

When it's dry, peel and rub the paper away and you should be left with a reversed transfer on the receiving surface. There are more exotic products on offer to achieve a similar effect, such as Golden Soft Gel Matte Medium, as well as special transfer papers for fabric and wood. Additionally, there are decal companies who can take your image and transform it into a waterslide transfer or a rub-down sheet to decorate ceramic surfaces.

TOTAL RECALL

SCIENTIFIC OPINION IS divided over the phenomenon of so-called photographic or "eidetic" memory. The standard test involves showing the subject a complex image for up to 30 seconds, then removing it and asking the subject to describe the image in detail. A minority of children appear to possess this ability, describing the image in the present tense as if it was still there. Doubt, however, is cast by research involving expert chess players who were shown extremely complex positions on a chess board, then asked what they could recall. They appeared to be extraordinarily successful with their recollections compared to a control group of non-players. However, when the board was re-set with the pieces replaced in impossible posi-tions, they fared no better than the control group. The suggestion is that another mechanism is at work, not photographic memory: their brains lock onto patterns they recognize from previous games, and a kind of mnemonic process is initiated.

The most controversial case involves Elizabeth Stromeyer. A researcher, who was later to become her husband, showed her a board with 10,000 apparently random dots, but with her left eye covered. The following day, she was presented with a similar board, but this time with her right eye covered, and immediately professed to see a floating stereoscopic image, having fused the left- and right-eye images. She steadfastly refused to repeat the test for any other researchers.

"I thought I made a mistake once, but it turned out it was a creative moment."

SCOTT FLEMING

FORGOTTEN, BUT NOT GONE

THE FIRST TIME A PHOTOGRAPH was transmitted by facsimile machine, the subject was a wanted man. The year was 1908, but the principle had been established in 1846 by Alexander Bain, a Scottish inventor. In 1861, Giovanni Caselli introduced a commercial "fax" service between Paris and Lyon. Wireless fax had to wait until 1924, when a portrait of President Coolidge was sent from New York to London. Current fax machines survive in high-security environments because of the fear of email interception during transmission over the internet.

AGENT PROVOCATEUR

THE MINOX SUBMINIATURE camera was invented in 1936 by Walter Zapp, a German living in Estonia (this modern Estonian stamp celebrates Zapp's original patent). Unable to get it manufactured locally, he eventually established production in neighboring Latvia, but during World War II, the factory was overrun, once by German forces and twice by the Russians. Production resumed in former West Germany in 1948, by which time the Minox had become the preferred equipment of real or imagined espionage agents worldwide. Grasping the attached measuring chain, the spy in a hurry could extend it to touch the secret item, shoot without using the viewfinder, and be assured of a sharp copy of, for example, an A4 or 8½ × 11 inch document. The Minox uses specially cut, unsprocketed film which is advanced each time the case is closed, an action which also protects the viewfinder and lens.

GUM BICHROMATE

SPECTACULARLY BEARDED Scottish inventor and author Mungo Ponton devised the Gum Bichromate printing process in 1839. It was later embraced enthusiastically by the Pictorialists, who valued the sometimes random color variations and combinations that could be achieved. The process uses chemicals markedly more toxic than the usual photographic mixtures, and extra care is needed.

ACRONYMS: P

P PROGRAM(ME) MODE: in which the camera varies aperture and shutter speed simultaneously to take account of different lighting conditions. The alternative settings are usually **A** (Aperture Priority), in which the aperture setting remains fixed while the shutter speed varies, and **S** (Shutter Priority) in which those priorities are reversed.

PHOBAR PHOTOSHOPPED BEYOND ALL RECOGNITION: of over-retouched digital images, derived from the vulgar military acronym FUBAR.

A SHADOWY PRESENCE

IN THE NOVEL *Caught in the light,* Robert Goddard borrows from the life of Elizabeth Fulhame, an obscure Scottish chemist known only for *An Essay on Combustion.* She was, however, also interested in light-sensitive chemicals, and was experimenting with silver salts in the 1790s, ten years before Thomas Wedgwood's "photograms," and 30 years before Niépce began his experiments. Her imaging researches went no further, but Goddard, through his invented character Marian Esguard, imagines an alternative photographic history, with priceless images waiting to be discovered.

Goddard himself summarizes, "Jarrett sets out to solve a mystery whose origins lie amid the magical-seeming properties of early photography. But at the end of his search a trap awaits him."

A BOOTH OF YOUR OWN

THE MODERN DIGITAL photo-booth lacks the mystique of its analog forebears. Although it's clearly marvelous to have your portrait rendered toot-sweet as a Warhol or a cross-hatched watercolor, you miss the explosive and unexpected flashes, and the aching tension of the wait by the delivery slot for the sticky strip of partial likenesses of you or the previous occupant. If you've got US$11,000 to burn, hurry to Hammacher Schlemmer on East 57th Street, NY, or get online. Tucked in between the Canine Genealogy Kit and the Remote Controlled Rolling Beverage Cooler is the Authentic Boardwalk Photo Booth. It plugs into the wall, and two rolls of film are included, enough for 800 lots of four-picture strips. Paradise regained.

> *"They used to photograph Shirley Temple through gauze.*
> *They should photograph me through linoleum."*
>
> TALLULAH BANKHEAD

ACRONYMS: Q

QR QUICK RELEASE: tripod-head device allowing instant detachment of the camera, also ***Quality Review*** (largely obsolete), the print-finishing department responsible for putting small sarcastic stickers on your prints when you've forgotten to remove the lens cap.

FORCED MARRIAGE

IF YOU REALLY LIKE early Leicas but crave the convenience of digital cameras, why not force one of the latter into one of the former? Nervous? Relax, it's already been done, by a Japanese enthusiast. The "Leica," most probably a Ukrainian clone, was disembowelled, and mated with the entrails of a Sony point-and-shoot digital camera. It works.

> *Some hate broccoli, some hate bacon*
> *I hate having my picture taken.*
> *How can your family claim to love you*
> *And then demand a picture of you ?*
>
> FREDERIC OGDEN NASH

GIMME SHELTER

FRENCH SHOE AND clothing group éram wielded a broad brush filled with vitriol for their 2010 bus-shelter campaign. The faux sticky label obscuring most of the model reads, "The photographer wanted a fortune. The model is on anti-depressants. The stylist makes out he's gay. All that for a pair of 49 euro boots." Other ads in the series allude to inappropriate relationships between the client, photographer, creative director, model and stylist, in various combinations.

Previous poster campaigns have included an ostrich in platform-soled boots, and a naked man in high heels along with the assertion that "no woman's body was exploited in the production of this advertisement." In all of these cases

© éram

the strapline is, "you'd have to be mad to spend more."

—— THE FIRST AIRCRAFT PHOTOGRAPH ——

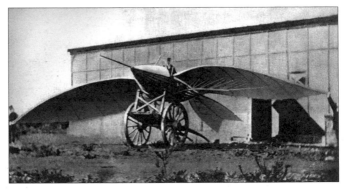

IN 1868, NADAR (pseudonym of Gaspar-Felix Tournachon, noted balloonist) took the first-known photograph of an aircraft, the *Albatros II,* built by Jean-Marie le Bris. The ALBATROS I had been a failure, but this second version managed a pilotless glide of 600 feet (180 m). le Bris broke his leg in a subsequent accident and gave up flying.

> *"Photography is like life... What does it all mean? I don't know—but you get an impression, a feeling... An impression of walking through the street, walking through the park, walking through life. I'm very suspicious of people who say they know what it means."*
>
> LEONARD FREED

—— ACRONYMS: R ——

RAW CAMERA RAW: not strictly an acronym, referring rather to the uncompressed camera file format which retains as much information as possible from the moment of exposure, *see p. 27.*

RC RESIN-COATED: type of photographic printing paper introduced in the 1970s. The coating prevented chemicals being absorbed into the paper base, thus shortening processing, washing, and drying cycles.

BAND OF BROTHERS

THE PHOTO LEAGUE WAS not the first organization to see cinema and photography as a political tool, but its members included many of the most influential US photographers from the mid-thirties until 1950. It began life as The Workers' Film and Photo League, itself inspired by Workers' International Relief, a communist group based in Berlin. The stated aims committed the group to "struggle against and expose reactionary film; to produce documentary films reflecting the lives and struggles of the American workers; and to spread and popularize the great artistic and revolutionary Soviet productions." In New York, the cinema and film membership split into two fraternal camps, with the still photographers being led by Paul Strand and Berenice Abbott. Recruits included Eliot Elisofon of *Life* magazine and the abstract expressionist photographer Aaron Siskind.

THE EARLY HISTORY OF PHOTOSHOP

THE WORLD'S MOST ubiquitous graphics program started out humbly packaged with a scanner in 1988, but its roots go back further. Brothers Thomas and John Knoll were steeped in photography by their father Glenn, a college professor with a home darkroom and an interest in computers. Knoll senior bought an Apple II Plus computer in 1978, and the brothers began to use it for their high-school work.

Later, Thomas graduated to a MacPlus but was frustrated by its inability to display grayscale (photographic) images on screen. In 1987, he wrote a program, later named Display, to force the machine into a grayscale mode. John Knoll, meanwhile, was working at the visual-effects studio Industrial Light and Magic, and asked his brother to help out writing code for movies. The Display software was modified for use with color and gradually acquired more sophisticated features, but Barneyscan was the only mainstream company to show an interest, issuing 200 copies as Barneyscan XP.

By 1989 there was a deal with Adobe, then principally working on type-related software, and Photoshop I was launched in February 1990. Thomas Knoll's name still appears on the opening screen of Photoshop CS5.

The young Thomas Knoll

——THE ETYMOLOGY OF PHOTOGRAPHY——

MOST OF THE WORDS WHICH describe photography had to be created from scratch, starting in the 1830s, though some arrived directly from the lexicon of painting.

ALBUM: from Latin *album* "white," referring to a blank tablet on which were recorded the principal events of the year.

BELLOWS: via late Old English *belwes* "bellies."

CAMERA: from Greek *kamara* "vaulted chamber" via Latin *camera*. The forerunner "camera obscura" (*see p. 29*) soon became abbreviated as the preferred word for the photograph-taking device.

CHIMPING: impolite analogy, dating from 1999, based on chimpanzee behavior. Ritualistically checking the digital display screen after every exposure.

DIAPHRAGM: from Greek *diaphragma* "the muscle dividing the thorax from the abdomen."

FOCUS: from Latin *focus* "hearth." Used in connection with optics from the late 18th century as an analogy for a meeting point or center of family life.

KODAK: invented by George Eastman and his mother using a set of letter tiles. Eastman wanted a short word that could not be mispronounced, and had no connections to any other word.

LENS: from Latin *lens* "lentil." An analogy based on the shape of a lentil.

NEGATIVE: from Latin *negare* "to deny," via Old French *négatif, négative.*

PANORAMA: from Greek *pan,* "all," and *horama,* "a view." Invented by Irish painter Robert Barker to describe a painting on a revolving cylindrical surface.

PHOTOGRAPHY: from Greek *phos* "light," and *graphos* "writing." Sir John Herschel used the word "photography" in his 1838 treatise *Note on the Art of Photography; or, the Application of the Chemical Rays of Light to the Purpose of Pictorial Representation*. He was unaware that Antoine Florence, a French painter living in Brazil, had described his own picture-making process as "photographie" in 1834.

PRINT: from old French *preinte*, past participle of "preindre," to press.

SHUTTER: first use in English 1862; SHUTTERBUG: in the sense of "enthusiastic amateur" dates from 1940.

SNAP: *see p. 6*

THE BIG PICTURE

THE WORLD RECORD FOR a photographic mosaic is currently held by an image displayed in Birmingham, England, in 2008. A total of 112,896 photographs were submitted and transformed into an mosaic of over 850 square meters. The overall image was of a local amateur boxer, photographed in the 1920s.

> *"I believe in equality for everyone, except reporters and photographers."*
>
> MAHATMA GANDHI

TO HELL IN A HORSE-DRAWN CART

THE CRIMEAN WAR PITTED the Russian Empire against the British and the French and their allies, in a struggle for influence over the declining Ottoman Empire. This conflict, lasting from October 1853 to February 1856, was the first in which photography was used as a tool of propaganda. Roger Fenton (b. 1819) had trained as a lawyer and as a painter, but became interested in photography following a visit to the Great Exhibition in London in 1851. He quickly established himself as a portrait and architectural photographer, and was instrumental in founding the Royal Photographic Society. In 1855, he was commissioned as official war photographer, with the express remit of countering the negative view of the Crimean War gained by the British public. His pictures include organized groups of infantrymen and portraits of officers,

but not, largely for technical reasons, the squalor and disease described by the anti-government London *Times* newspaper. After the war he continued as a photographer, but gave up in disillusion in 1862 and returned to the law.

Fenton's assistant, Marcus Sparling, with the converted wine delivery cart they used as a darkroom

ACRONYMS: S

SD, SDHC SECURE DIGITAL, SECURE DIGITAL HIGH CAPACITY: very small photographic memory cards, smaller than the original Compact Flash cards, more convenient and infinitely easier to lose down the back of the sofa.

SRGB STANDARD RGB: color space devised in 1996 by Microsoft and Hewlett Packard, and now by far the most used for monitors, scanners and printers, despite its gamut being smaller than that of the rival Adobe RGB.

> *"It was soon evident in my lodgings that I had become a dangerous lunatic, and there would be nothing left to destroy if strong measures were not taken. So I was turned out of the house, but it was only into the garden, where I was allowed to build a small darkroom of oilcloth."*
>
> HENRY PEACH ROBINSON (*see p. 7*)

IN THE DRINK

THE DIFFICULTY OF SEALING an underwater camera defeated photographers until 1856, when William Thompson managed some murky pictures in shallow water off Weymouth. The ubiquitous Eadweard Muybridge (*see p. 8*) followed suit in California in the 1870s. By the 1930s, several purpose-made underwater cameras had appeared, and in 1949, Franke & Heidecke (*see p. 48*) introduced this Rolleimarin housing, designed by Hans Hass to contain a Rolleiflex. In 1953, Harold Edgerton adapted his stroboscopic high-intensity lighting system for underwater use, in collaboration with Jacques-Yves Cousteau. The Nikon company introduced the 35mm Nikonos I

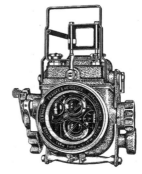

in 1963, a development of Jean de Wouters' CalypsoPhot design, and their SR single-lens reflex model in 1992. These self-contained cameras have been overtaken once again by purpose-made housings, this time to accommodate digital cameras, even humble point-and-shoot models.

IN THE ZONE

A NSEL ADAMS AND HIS confederate Fred Archer devised the Zone System in 1939. Their efforts, which had begun with a series of magazine articles by Archer, led to a codification of the various degrees of luminance in a scene. The method was devised with large-format photography in mind, but the discipline is still useful in digital photography. It begins with a chart:

The 11 degrees of luminance are represented by Roman numerals from 0 (full black) to X (pure white) and each one is different from its neighbor by a factor of two—a whole f-stop, in fact. Intermediate tones are described in photographic terms, such as value V "middle gray: clear north sky; dark skin; average weathered wood." The first step is to visualize the lightest area of the finished print which needs to retain detail and ascribe it to zone VII, for example, described as "very light skin; shadows in snow with acute side lighting." Note the meter reading in your viewfinder or separate exposure meter. The meter will try to "place" the exposure in the middle of the tonal scale—zone V in the Zone System—but a light area will print too dark at that setting. Zones V and VII differ by two steps in the chart, so an additional two stops' exposure should be given. Adams and the view-camera aficionados had, and still have, the possibility of manipulating the development of an individual negative to extend its tonal range, followed by selective exposure (*see p. 85*), and development of the print.

IN THE DARK

A PROFESSIONAL STUDIO photographer who got sidetracked by the decline of steam traction on a railroad in Virginia, O. Winston Link produced a series of large-scale photographs recording the last days of the Norfolk & Western's steam locomotives. The majority were shot at night, using enormous banks of flashbulbs and up to three cameras, all electrically linked. After the complete disappearance of steam in 1960, Link returned to regular photography, and his railroad pictures remained in obscurity until the 1980s.

In 1987 *Steam, Steel and Stars,* a book with a selection of his pictures, rekindled public interest, and made his prints very desirable, so much so that his second wife began stealing them from his darkroom. She and her accomplice were eventually jailed for grand larceny.

THE SOFT LIFE

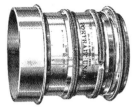

THIS BAUSCH & LOMB Unar lens of 1904 typifies the then common adjustable portrait lens. It is of conventional construction, but an additional graduated ring around the lens mount allows the spacing between the rear elements to be varied. The result is increasing spherical aberration, and a decreasing area of sharp focus in the center.

The maker's catalog explains, "for this [the making of cabinet portraits] the photographer requires a certain amount of softness so that, if we focus upon the eyes with a Portrait Unar, the ears and nose are soft enough not to detract from the general effect... should you require further softness you can use the diffusing device, which gives varying degrees of softness as the indicator on the device is moved from No. 1 toward No. 4." Such a lens for use with a whole-plate camera was priced at US$200—the equivalent of US$3,750 at today's prices. Cheaper alternatives involved the use of vaseline on the lens's front element, but the effect was rather hard to control, and even harder to repeat.

The Unar's descendant in the 21st century is the Lensbaby. It features a ball-and-socket device so the center of sharp focus can be moved around the frame, and one modular version can be used with or without the camera's own lens attached. Prices run from US$100 to US$350.

160 MP AND COUNTING

THE SWISS-MADE SEITZ 6 × 17 digital camera uses a scanning sensor behind the lens to capture a panoramic image. During the scan, which typically lasts around a second, an incremental image of 160 megapixels is produced, then transmitted by ethernet cable or wireless to a dedicated computer. For the record, the image is 21,250 pixels wide and 7,500 pixels deep. A modular system allows the digital scanning back to be removed and used on other compatible cameras. The whole kit costs about the same as a mid-range family car.

NIPPON KOGAKU KOGYO KABUSHIKIGAISHA

THE COMPANY (above) NOW known as Nikon was founded in 1917 by the merger of three optical enterprises. The greater part of the business was in microscopy, binoculars and periscopes for the miltary, and, from 1933, lensmaking for other manufacturers, including Canon, their eventual industrial rival. The company's first camera was introduced in 1948, a 35mm interchangeable-lens rangefinder mode which attempted to synthesize the best features of the established Contax and Leica brands, though looking very much more like the former than the latter. It was named "Nikon" at the last minute, but was obliged under the terms of the post-war treaty to be engraved "Made in Occupied Japan" on the base-plate. In 1959 the ground-breaking Nikon F arrived, not the first single-lens reflex, but the first to offer a full-frame viewfinder, a comprehensive range of lenses and an optional motor-drive. It instantly became the professional photographer's machine of choice, and its rangefinder rivals shuffled off in the direction of the collectible camera auctions. By 2011, Nikon had become the dominant SLR manufacturer both in Japan and worldwide, ahead of its closest rivals, Canon and Pentax.

"I have for a long time entertained the opinion that the accepted theory of the relative positions of the feet of horses in rapid motion was erroneous. I also believed that the camera could be utilized to demonstrate that fact, and by instantaneous pictures show the actual position of the limbs at each instant of the stride."

from Leland Stanford's preface to The Horse in Motion, author credited as Dr. J. D. B. Stillman.

It continues:

"Under this conviction I employed Mr. Muybridge, a very skilful photographer, to institute a series of experiments to that end."

Apart from two or three references in the text, Muybridge's name is almost entirely absent from the book, though full of his images. This was the beginning of their long-running feud, and the reason that Muybridge published his researches separately, in the expanded *Human and Animal Locomotion*

DOUBLE VISION

MATHEW CAREY-LEA, a pioneering chemist in the early years of photography in the USA, conducted extensive research into the uses and properties of silver in the photographic process. A devotee of the metric system, and frustrated by his scientific compatriots' dogged adherence to the "Customary System" of weights and measures, he excoriated them as follows:

"The French system of weights and measures is sure to be eventually adopted by the American people, unless, indeed, we are prepared to admit that we are slower to improve than the nations of continental Europe... Our present system is a disgrace. It is so bad that nothing but old habit induces us to submit to it."

A. H. WALL, a contemporary of Carey-Lea and writer on photographic subjects, imagined a world without the stink of noxious chemicals in the darkroom, but spoke 120 years too soon:

"Photographers cannot long go on in the old ruck of baths and processes. There must come a time when these things will be exhausted."

SOME LEGAL NICETIES

IN THE UNITED KINGDOM, a person has the right to take photographs in public places, and, while in a public place, to take photographs of private property, except of military installations and airfields. There is no restriction on taking pictures of other people in public places, though pursuit of a particular person might lead to a charge of harassment and a possible six-month prison sentence. A court has recently held that the right of privacy of a child might be infringed by the taking and publishing of a photograph of him with his parents in a public street. Photography within a court of law, or its precincts is forbidden. Additionally, it is an offense to publish any image of a young person under 18 who is involved in any legal proceedings, whether as a party or as a witness.

In Trafalgar Square and Parliament Square there is a specific ban on taking commercial photographs unless with paid permission from the Greater London Authority. Similar conditions apply in the Royal Parks. It is an offense to take a photograph of a UK banknote, and to disturb any protected bird species in an attempt to photograph them. Photographers have been stopped on occasion by police who quote the section 44 of the Prevention of Terrorism Act in what seem to be footling circumstances. This section of the Act was deemed illegal by the European Court of Human Rights, and the then government's appeal was disallowed in 2010. The case continues...

DOUBLE VISION

THE PHOTOSPHÈRE NO. 4 stéréoscopique is based on the single-lens Photosphère I camera of 1888 designed by Napoléon Conti. It was made entirely of oxidized brass by the Compagnie Française de Photographie for use in the tropics. According to the contemporary publicity, "the Photosphère is the world's most practical, lightest, simplest, best-made and most perfect camera." The French explorer Captain Louis-Gustave Binger used a Photosphère with great success during his 1891 expedition from Senegal to the Niger River.

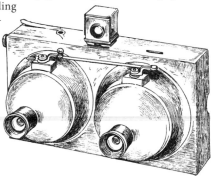

FIGHTING FASCISM

JOHN HEARTFIELD WAS born Helmut Herzfelde in Berlin in 1891, but anglicized his name in 1916 in protest at the anti-British sentiment of the time. In 1917 he allied himself with the Dada surrealist movement and joined the Communist Party. His experiments with photomontage began in the 1920s under the influence of the artist George Grosz. Heartfield's posters, satirizing Hitler and the Nazi leadership, combined newspaper photographs and the artist's own specially made pictures. Under pressure from the authorities, Heartfield left Germany, first for Prague, and later London. In the 1950s he made a heroic return to the then German Democratic Republic.

> "Always point your finger at the chest of the person with whom you are being photographed. You will appear dynamic. And no photo editor can crop you from the picture."
>
> KEN AULETTA

PHOTOGRAPHING ON WOOD
FROM *THE PHILADELPHIA PHOTOGRAPHER*, 1867

THOSE WHO DESIRE TO TRY to make photographs on wood, will, in the beginning, recollect that more depends upon care and cleanliness than upon the details of the process. They are very easy to make, if this fact be borne in mind and carefully practiced. The negatives are made in the usual way, except that they are reversed by the use of an extra glass. This is done in order to make the impression from the wood-cut appear properly.

To prepare the blocks, which are, of course, box-wood, such as is commonly used by engravers, saturate them in melted white wax, permitting them to remain in it a few seconds only. Scrape the wax off the block with a scraper, clean the surface with turpentine, and coat it with flake white in the way practiced by engravers. This is done merely to give the block a white surface, and to make it more easy to watch the printing as it progresses. The block is then flowed with a solution of water 3 parts, albumen 3 parts, and salt 3 grains to the ounce of water and albumen. It is then dried, and with a piece of paper a second solution is poured over the surface of the block, of silver, 15 grains to the ounce of water, glacial acetic acid, 2 drops to the ounce, and just enough gelatin to give the solution the consistency of oil. After again drying the block thoroughly, fume it about fifteen minutes, and print in the usual way. After printing, the blocks are treated almost exactly as paper prints. They are toned, as follows: Dissolve 45 grains of hyposulphite of soda in 32 oz. water, then dissolve 15 grains chloride of gold in 16 oz. water, and add it, little by little, to the hypo solution. Shake well, and when the mixture becomes clear as water, it is ready for use. Fix with hypo soda. By this simple and easy process, quite a revulsion *[sic]* is being made in wood-cutting, much to the improvement of the pictures.

ABSOLUTELY FRANK

SWISS-BORN ROBERT FRANK emigrated to the USA in 1947, already committed to photography as a force for social change. With a grant from the Guggenheim Foundation, he set off across the USA in 1955, taking over 28,000 photographs. Of these, he selected only 83 for his controversial book *The Americans*, for which Jack Kerouac wrote the foreword. Turning to film in the 1970s, he made *Cocksucker Blues*, a movie of the Rolling Stones' 1972 tour. A dispute over the copyright ownership of the film led to a compromise legal judgment that it could only be shown five times a year, and then only if Robert Frank was present.

FILM NOIR

AUSTRALIAN WRITER AND film-maker Ross Gibson spent five years, on and off, closeted in the photographic archive of the Sydney Justice and Police Museum, among half a million negatives which had been saved from a flood-damaged warehouse. During the rescue, the pictures, from the 1940s and 1950s, had become separated from their case-files. Gibson's initial brief was to curate an exhibition of a selection of these sometimes grisly scenes. That job done, he began to incorporate 175 of the photographs into a novel narrated, not by Gibson himself, but by his virtuous *alter ego*, a saintly chaplain. The book, *The Summer Exercises*, and its pictures, are strong medicine: Delia Falconer reviewed it in *The Australian* and referred to "Sydney's crimes [that] often seem more a chthonic [pertaining to the underworld] eruption of feral rot; the acting out of a metropolis that, for all its shining endowments, has never experienced a golden age."

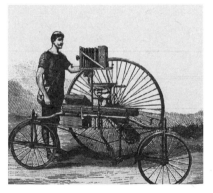

THE EXPLOITS OF Thomas *Stevens, recounted in his 1886 Around the World on a Bicycle, inspired a generation of adventurers to take to two, or in this case, three wheels, with camera at the ready. After an extremely arduous day roaming the countryside in search of the ideal location for a self-portrait, the exhausted but resourceful cyclist could settle down to a quiet evening processing the results beneath his folding darkroom umbrella.*

–"ADMIRABLE, EXPRESSIVE AND VIGOROUS"–

THE PIONEERS OF PHOTOGRAPHY were almost all men, but one Englishwoman, Julia Margaret Cameron, justifies her place in the roll of honor by force of personality, bloody-mindedness and artistic ambition. The comments in the title above continue, "...but dreadfully opposed to photographic conventions and proprieties."

Given a camera for the first time at the age of 49, she launched herself into photography with little regard for the technicalities, but with a strong vision for portraiture and composition, based squarely on the ideas and medieval allegories of the pre-Raphælite movement. Her friend, the author and fellow photographic enthusiast Lewis Carroll, poisonously observed, "In the evening Mrs. Cameron and I had a mutual exhibition of photographs. Hers are all taken purposely out of focus—some are very picturesque —some merely hideous—however, she talks of them as if they were triumphs of art."

She preferred low light levels in the studio, so her sitters were detained for even longer exposures than were usual in the 1860s, and were not excused their fixed poses during the time it took to develop the succession of collodion plates. Dimbola Lodge, her house on the Isle of Wight, is open to the public, and contains a photographic museum.

———— ON THE GRAND SCALE ————

CARLETON WATKINS FOLLOWED the California Gold Rush in 1851, but finished up working in a book shop. However, an encounter with Robert Vance, a San Francisco photographer, eventually led to a new career. After starting out as a freelance police photographer, he eventually became noted for his pictures of the American West, using 18 × 22 inch "mammoth" plates, coated with collodion in the field. He also made and marketed a vast collection of stereoscopic views which were so successful that they were pirated by operators based on the East Coast. His business failed in the crash of 1875, but retrenched with a new series of Western views. His studio and negatives were finally lost in the San Francisco earthquake of 1906.

"My best shot on a 36 exposure roll seems to be on the 37th frame."
BILL HORAN

THE HUMAN MOSAIC

DURING WORLD WAR I, the propaganda arm of the US military was fortunate in having the services of Arthur Mole, an immigrant English commercial artist. Mole had first established the human mosaic idea in a biblical context, marshaling fellow-parishioners to represent the shapes of religious symbols. For the US army, he operated on a much larger scale, viewing the scene on a glass plate carrying the design sketch, and directing his assistants from an 80-foot tower as they laid out white string guides for the troops who would arrive later. There are 30,000 men in this picture.

───────────── ACRONYMS: T ─────────────

TIF(F) TAGGED IMAGE FILE (FORMAT): a file format developed in 1986 by Aldus (now absorbed by Adobe) as a standard output format for scanners. It was upgraded in 1988 to allow file compression, and is still in widespread use despite no enhancements since 1992.

T TIME: a camera-shutter setting with which the shutter opens on the first press, and closes on the second. The adjacent "B" setting keeps the shutter open until the button is released.

T*TRANSPARENT: anti-reflective lens-coating process developed by the Carl Zeiss company (*see p. 93*) of Jena in 1935.

───────────── UNBRIDLED EMULSION ─────────────

CHARLES-FRANÇOIS TIPHAIGNE de la Roche wrote *Giphantia* in 1761. The title is an anagram of his name, and contains a curious passage which seems to presage photography, or rather the coating of a surface to establish the photographic image. The narrator is guided around Giphantia, an "island in an ocean of moving sands" by the Prefect of the place:

> "the elementary spirits (continued the Prefect), are not so able painters as naturalists; thou shalt judge by their way of working. Thou knowest that the rays of light, reflected from different bodies, make a picture and paint the bodies upon all polished surfaces, on the retina of the eye, for instance, on water, on glass. The elementary spirits have studied to fix these transient images: they have composed a most subtile matter, very viscous, and proper to harden and dry, by the help of which a picture is made in the twinkling of an eye. They do cover with this matter a piece of canvas, and hold it before the objects they have a mind to paint. The first effect of the canvas is that of a mirrour; there are seen upon it all the bodies far and near whose image the light can transmit. But what the glass cannot do, the canvas, by means of the viscous matter, retains the images. The mirrour shows the images exactly; but keeps none; oure canvases show them with the same exactness and retain them all. The impression of the image is made the first instant they are received on the canvas, which is immediately carried away into some dark place; an hour after the subtile matter dries, and you have a picture so much the more valuable, as it cannot be imitated by art or damaged by time."

FROM LOMO TO LACOCK

M ANY PROCESSES WERE invented and discarded at the beginning of photography. A strong survivor is the wet-collodion method, based on the potentially explosive combination of nitro-cellulose (gun-cotton) and ethyl ether. Among leading modern practitioners is Richard Cynan Jones. He explains how he became immersed in this beautiful and painstaking technique, "I was happily shooting pictures with a digital camera when I came across the Lomo web-site, and was inspired to join in. The subversive 'anti-photography' attitude appealed to me, and I bought a Lomo LC-A, and then a Holga. Both make pictures with glorious faults: colour shifts, flare, out-of-focus effects, vignetting, you name it. It got me interested in the roots of photography, especially alternative printing processes. I started making cyanotypes from large acetate negatives produced on the computer from the Holga pictures. The great thing was that I could make contact prints without a darkroom.

"I liked the idea of the photograph as an artifact, with its own weight and texture, and wanted to be much more hands-on. I moved up the formats with a scruffy Russian 5 × 7 inch stand camera and started making my own dry gelatin plates with liquid emulsion. They're very insensitive—around ISO 1 or 2—so it's very much like the early days. The real turning point was seeing Robb Kendrick on TV travelling around making wet collodion tin-type portraits of cowboys. I was hooked, it was so direct, almost like a Polaroid.

"Before long, I had downloaded the old processing manuals from the internet, got a better camera [made by Ray Morgenweck, *see p. 92*], with a Petzval lens bought on eBay and carefully repaired, and started photographing local people. I fitted out a kind of trolley-cart to use as a travelling darkroom, and loaded it into a van. One day, Welsh TV asked me to shoot at a burlesque show featuring a dancer named Scarlet Fever. A friend of hers later mentioned me to a

Wet-collodion portrait,
10 seconds at f5.6.

re-enactment company involved with celebrating the 175th anniversary of Fox Talbot's first 'photogenic drawing'. So, I found myself in front of the famous lattice window at Lacock Abbey, ready to re-create the moment. It worked very well, and I now do demonstrations and courses using early processes at the Fox Talbot Museum. The next thing is the Daguerreotype..."

Lady (who is posing and rather tired), "OH, MY DEAR MR. DOOLAN, HAVEN'T YOU YET GOT IT RIGHT FOR TAKING ME?"

Mr. Doolan (amateur photographer), "MY DEAR LADY, IT'LL BE FINE! YOU'RE JUST IN THE VERY ATTITUDE! COME ROUND NOW AND SEE FOR YOURSELF!"

BILL BRANDT

A FTER A SICKLY CHILDHOOD IN Austria, Bill Brandt's fortunes took an upward turn with an introduction to Man Ray (*see p. 85*). He became his assistant in Paris, then moved to Britain in 1933. He worked extensively as a photographer for *Picture Post* and on a documentary series of pictures of the 1940 London blitz, but is best remembered for his distinctive nude photography, often set in land- or seascapes echoing the human form.

> "I was photographing the D-Day landings when a voice said, 'If you take one more step back, you'll blow us both to smithereens. There's a mine behind you!' It's so easy to forget reality when you are holding a camera to your eye. The rest of the world doesn't seem to exist."
>
> SLIM HEWITT

"If you cannot see at a glance the old game is up,
that the camera has hopelessly beaten the pencil and paintbrush
as an instrument of artistic representation,
then you will never make a true critic;
you are only, as most critics, a picture fancier."

GEORGE BERNARD SHAW,
quoted in *The Amateur Photographer*, October 11, 1901

LEADER OF THE PACK

ALFRED STIEGLITZ WAS INSTRUMENTAL in the struggle to promote photography as an art form. Born in the USA in 1864, he trained as an engineer in Germany, but was more interested in photo-chemistry. He fondly described his first purchase of a camera, "I bought it and carried it to my room and began to fool around with it. It fascinated me, first as a passion, then as an obsession."
He remained in Germany during the 1880s, living on an allowance from his father, but the latter recalled him, very unwilling, to the USA in 1890 to help deal with a family bereavement. Setting up in business, once again with the help of his father, he soon began broadcasting his opinions on photography via the columns of *The American Amateur Photographer*.

On a honeymoon trip to Europe, Stieglitz met the British founders of the "Linked Ring," an invitation-only group of photographers established after a major disagreement within the hierarchy of the Photographic Society (later The Royal Photographic Society). The argument turned on the Society's unwillingness to accept that photography had an artistic dimension. Stieglitz was invited to join the Linked Ring, and used this new distinction to galvanize like-minded photographers in the USA into standing up for the principles of what had become known as "Pictorialism." As vice-president of the prestigious Camera Club, he mounted exhibitions (including one featuring Edward Steichen, *see p. 78*) and edited the club magazine. However, his dominance upset many members, and he resigned in 1901.

The following year, ill, but undaunted, he invited favored photographers to submit work for an exhibition entitled "Photo-Secession" at the New York Arts Club. Gertrude Käsebier (*see p. 79*) asked Stieglitz, "am I a Photo-Secessionist?" "Do you feel that you are?" riposted Stieglitz. "I do," she said. "Well, that's all there is to it," came the reply. Stieglitz continued to be a powerful influence until the 1940s, still setting up groups and disbanding them in disgust at disloyalty. He died in 1946, and his second wife, Georgia O'Keeffe, took charge of organizing his legacy of 3,000 prints and 50,000 letters.

THE MISCELLANY MAN

NO-ONE COULD BE BETTER qualified to be included in a book of this sort than the multi-talented Noel Pemberton-Billing. Born in Birmingham in 1881, he ran away from home aged 14 and worked his passage on a freighter to South Africa. Once there, he worked variously as a bricklayer, tram conductor and mounted policeman. Returning to England, he started a garage business, qualified, but didn't practice, as a lawyer, and became a steam-yacht salesman. After a successful bet with Frederick Handley-Page that he could learn to fly solo in a day, he set up an aviation enterprise that would ultimately become Supermarine, makers of the Spitfire, though Pemberton-Billing had left the company long before its development began.

He was an MP during World War I, but also served in the Royal Navy, organizing bombing raids on the Zeppelin factory. He was the successful defendant in a notorious libel case in 1918. Among the evidence he submitted in his defense was the allegation that the German secret service was black-mailing "47,000 highly placed British perverts" in order to undermine the war effort. By the 1930s he had written a play, *High Treason,* and invented the long-playing record, the patent for which was bought by HMV and suppressed for 20 years.

And then there was the camera, the Compass, designed by Pemberton-Billing and produced by Swiss jewellers LeCoultre in 1937. Equipped with a retractable lens, built-in filters, two viewfind-ers, interchangeable film back, exposure meter and swiveling panorama tripod bush, the first model retailed for US$48 (now about US$2,315) in 1937. Its designer died in 1948.

BY ROYAL APPOINTMENT

INITIATED INTO PHOTOGRAPHY BY his nanny, Cecil Beaton got an intro-duction to high society through David Tennant, who was one of "The Bright Young Things," and later famous for allegedly spending the last 17 years of his life in bed. Beaton often photographed the Royal Family, especially Queen Elizabeth the Queen Mother, whose image he subtly improved throughout the 1950s and 1960s. He was also active in stage design, though failing during a period of over 30 years to write the play he aspired to. Nevertheless, he was an excellent diarist, caricaturist, costume designer (*My Fair Lady* and *Gigi* among his film credits) as well as enthusiastic lover of celebrities including Adèle Astaire, Coral Browne, and Greta Garbo.

OPPOSING ELEMENTS

JOSEPH PETZVAL'S FAMILY intended him to be a shoemaker, but he narrowly escaped this pedestrian fate for a career as a physicist. Born in Upper Hungary (now Slovakia), Petzval was eventually appointed to the chair of mathematics at the University of Vienna.

In 1840 he designed a new photographic lens, the first to be devised mathematically rather than by trial-and-error. Its use of two elements cemented together (a doublet) was not novel, but its much larger working aperture made it an instant success, especially with portrait photographers. The typical exposure for a Daguerrotype was reduced from several minutes to a few seconds. Before long, Petzval had a major dispute with Peter Voigtländer, to whom he had licensed the actual manufacture of the lens, and began to look for other, more scrupulous, business partners.

Petzval's next design, the Orthoscope, though properly patented this time, was pirated and renamed by the extremely persistent Voigtländer. Petzval's new partners, unable to compete with Voigtländer's superior industrial and marketing expertise, duly went bankrupt. Petzval's misfortunes culminated in a burglary in 1859 during which he lost all his manuscripts, including a major unpublished work on optical science. Understandably, he gave up the study of optics in favor of acoustics. However, in the 21st century, a Petzval lens, with its sharply focused central area and soft edges, is still a coveted device among large-format and ancient-process photographers, while the name of Voigtländer now exists only as a licensed brand.

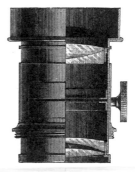

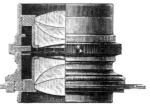

The Petzval portrait lens (above), *with its two widely separated doublet elements which compensate each other's aberrations, and* (below) *Voigtländer's Kollinear lens, based on the patent of Steinheil, yet another rival lens designer.*

"You don't have to sleep with the photographer, although it helps at times."
MARIE HELVIN

MANY GLANDS MAKE LIGHT WORK

WHEN ALL PHOTOGRAPHIC LIGHTING fails, but the picture must be taken, why not emulate Dr. John Vansant of the United States Marine Hospital in St. Louis? In 1887 he captured a dozen fireflies and was able to make a photograph by the light coming from under their abdomens. He estimated the duration of the flash of each insect at half a second, and set the necessary exposure at 50 flashes. The US military is still researching firefly and plankton bioluminescence as navigation aids.

CLOSE TO THE EARTH

YANN ARTHUS-BERTRAND HAS been an actor, film director and wildlife park manager. While in Kenya photographing lions, he took a trip in a hot-air balloon. This proved a turning-point: back in his native Paris, he founded the Altitude aerial photo agency in 1991. The *Earth from the Air* project, a UNESCO commission, began three years later, and resulted in a best-selling book. The

pictures are mostly shot from a helicopter from 2,000 meters all the way down to 20. The keynote image in the book is a heart-shaped clearing in a mangrove swamp on the South Pacific island of New Caledonia, and the caption speaks of the swamp's probable disappearance in the face of development and pollution. A free traveling exhibition of giant prints from the book has now visited over 100 cities, from Lyon to Montreal, and been visited by over 120 million people, to raise awareness of climate change and pollution.

> *"I drifted into photography like one drifts into prostitution.*
> *First I did it to please myself, then I did it to please my friends,*
> *and eventually I did it for the money."*
>
> PHILIPPE HALSMAN

ACRONYMS: U

UD ULTRA-LOW DISPERSION: made with the addition of rare earths, UD glass has a lower refractive index than common lens glass. It is used in conjunction with fluorite glass in high-quality lenses.

UL UNDERWRITERS LABORATORIES: two letters in a circle, engraved on equipment to show it meets the safety regulations of the Underwriters Laboratories of the USA.

SHOOTING STARS

A STROPHOTOGRAPHERS WERE the last to give up the antiquated business of using large sensitized glass plates, because they appreciated the stability of glass compared with film. However, market forces intervened in the late 1990s when Kodak stopped supplying the plates.

Louis Daguerre started the history of astrophotography in 1838 with this picture of the moon, made at the request of the astronomer François Arago. The two difficulties, then as now, lay in recording at very low light levels, and in accurately tracking the moving celestial objects during exposure. Once the tracking problem had been overcome, much longer exposures could be made, and images of extremely faint objects began to appear. The early 20th century saw the introduction of giant fixed telescopes like the 100-inch reflector on Mount Wilson in California. Although color film was becoming available, astronomers stuck doggedly to monochrome for its single-layer precision and much greater sensitivity: if color was needed, the favored technique was to make three separate exposures through a series of tri-color filters, and combine the results afterwards.

Current developments involve digital imaging and even more enormous reflectors—the Gran Canaria telescope has a 10.4 meter mirror (409 inches compared with Mount Wilson's 100). In early 2011 the Sloan Digital Sky Survey published its trillion-pixel image of over one quarter of the sky, gathered as a mosaic over 11 years. However, the amateur astrophotographer can still contribute, with the aid of a telescope and a motor-driven equatorial mount, used with a telescope and/or a camera. A much lower-tech solution has two flaps hinged together, with the equipment mounted on one flap, and the other flap fixed. A screw thread is slowly turned by hand to move the equipment to follow the star movement during the exposure. Per ardua ad astra.

EDWARD STEICHEN

BORN IN LUXEMBOURG IN 1879, Edward Steichen eventually became one of the most celebrated figures in American photography. He and his family emigrated to the USA in 1880, and finally settled in Milwaukee. Working at a print-shop in the city, he began to dabble in photography in the 1890s, and by the end of the century was a committed Pictorialist in the manner of Edward Stieglitz (*see p. 73*). He joined the latter's Photo-Secession movement, and designed its *Camera Work* magazine. He had always been a painter, and his work at that time often combined the two media, with colored washes and abraded surfaces.

By 1903, Steichen had a successful studio in New York. Appointed chief photographer at Condé-Nast in 1923, he shot high fashion for *Vogue* and celebrities for *Vanity Fair*, while maintaining his commercial business in parallel. Bath soap, sugar and matchbox manufacturers all benefited from his skill, characterized by masterful lighting setups and elegant composition. Simultaneous and apparently effortless success in both "art" and "commercial" photography attracted criticism from all quarters, but Steichen ignored it. *Vanity Fair* folded in 1935 (though revived in 1983) and Steichen largely gave up commercial photography. After World War II, he was appointed Director of the Department of Photography at the Museum of Modern Art, New York. It looked like his swan-song, but in fact he excelled himself there, curating the 1955 *Family of Man* exhibition of over 500 pictures by nearly 300 photographers. The display subsequently spent eight years on the road, visiting 37 countries, eventually finding a permanent home in the castle in the village of Clervaux, Steichen's birthplace. Steichen died in 1973.

A SLIDE INTO OBLIVION

THE MOST POPULAR COLOR transparency film in the world is no more. Kodachrome, initially a movie film, was introduced for still cameras in September 1936: production ceased in June 2009. It was appreciated for being warmer-toned than Ektachrome (which survives) and for its archival qualities. Though Paul Simon famously sang disparagingly of its "nice bright colors," it actually gave a less thoroughly saturated result than Fuji's rival Velvia, which also survives, but only after a riot by customers when it was discontinued. Dwayne's Photo, of Parsons, Kansas, accepted Kodachrome for processing until 12 noon on December 30th 2010. It was utterly inundated.

GERTRUDE KÄSEBIER

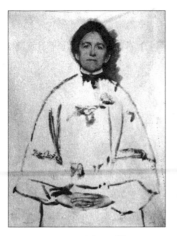

THE LIFE OF GERTRUDE KÄSEBIER, the leading US female photographer around the end of the 19th century, has parallels with that of Julia Margaret Cameron (*see p. 68*). They both came to photography late in life, and shared a similar artistic vision. Gertrude Käsebier, however, was by far the superior technician, having traveled to Germany specifically to study photo-chemistry. In 1899, she was praised by the influential photographer Alfred Stieglitz (*see p. 73*) who described her as "beyond dispute, the leading artistic portrait photographer of the day." She soon became a member of his Photo-Secession group. This self-portrait, combining photography and drawing, exemplifies the Secessionists' desire to break away from the staid Victorian style of the day. A very unhappy relationship with her husband inspired her photograph of two oxen. It's entitled "Yoked and Muzzled—Marriage."

PRODUCED BY THE CHICAGO Ferrotype Company in 1913, the Mandel-ette produced a finished photograph in one minute thanks to a built-in processing tank.

"The 'Mandel-ette' received and opened up, and in 20 minutes I had a splendid picture of my wife, fully developed and ready to look at. My, this beats all things yet."

T. J. HOUTS

Pastor, Methodist Episcopal Church, Welch. W. VA.

> *"Photography concentrates one's eye on the superficial. For that
> reason it obscures the hidden life which glimmers through the outlines
> of things like a play of light and shade. One can't catch that even
> with the sharpest lens. One has to grope for it by feeling."*
>
> FRANZ KAFKA

MR. DOBBS, AT THE request of his Affianced, sits for his Photograph.
Unconsciously, he happens in at Mumler's. Result—portrait of DOBBS
with his FIVE DECEASED WIVES IN SPIRITUO ! ! ! *(see opposite)*

SHAPED BY WAR

> *"I am sometimes accused by my peers of printing my pictures
> too dark. All I can say is that it goes with the mood of melancholy
> that is induced by witnessing at close quarters such intractable
> situations of conflict and joylessness."*

DON MCCULLIN'S MELANCHOLIA is understandable. He went to Vietnam
15 times, starting in 1965, covered the Biafran war in 1969, and was fired after
17 years by incoming *Sunday Times* editor Andrew Neil on the grounds that
his pictures were too depressing.

——— SUSPENSION OF DISBELIEF ———

THIS SMALL SELECTION unites some of the fakery perpetrated during the near 200-year history of photography. All of it was achieved without the help of digital alteration.

THE LOCH NESS MONSTER: by Dr. R. Kenneth Wilson. Made in 1934 but not properly unmasked until 1975, when one of his descendants admitted that the monster was nothing more than a carved wooden neck attached to a toy submarine.

THE COTTINGLEY FAIRIES: by Elsie Wright and Frances Griffiths. In 1917, these Yorkshire cousins borrowed Elsie's father's plate camera and produced a number of self-portraits garnished with 8-inch tall dancing fairies carefully cut from a contemporary children's book. Sir Arthur Conan Doyle, an ardent spiritualist, defended the two girls against allegations of deceit. Over 70 years elapsed before they both admitted it was a trick, using hatpins and bits of string to support the figures.

FLYING SAUCER: by many enthusiastic and apparently trustworthy individuals. Usually an innocent sighting of a weather balloon or unusual cloud formation, but sometimes a pie-tin or hub-cap tossed by an off-camera assistant. The classic saucer-shape dates from a magazine cover of 1911, and was appropriated by mythologizers in the 1950s. Their story has a top-secret division of the SS developing flying machines at an Antarctic base, with help from collaborators based on the star Aldebaran, 65 light-years distant.

SPIRIT PHOTOGRAPHS: by William H. Mumler. Tried for fraud, but acquitted, in Boston in 1869, Mumler maintained that ghostly presences appeared unbidden alongside his sitters, as in this portrait of Moses A. Dow, editor of *Waverley* magazine, accompanied by the affectionate spirit of Mabel Warren, his late assistant and protegée.

THE LOAN WOLF: by José Luís Rodriguez. The prizewinning picture in the £10,000 Natural History Museum's Wildlife Photographer of the Year competition (*see p. 17*) was finally denounced as fraudulent when the supposedly wild wolf portrayed was identified as a trained animal hired in from a Spanish zoo park.

DIARY OF A NOBODY CO-WRITER George Grossmith Jnr. wrote this song for "imitation banjo" accompaniment. It reflects the undying public conviction that the photographer has a better time than the rest of us. A brutal précis of the seven verses:

❧

Miss Jenkins was a lovely maid in Kensington located,
And there never was a fellow who could win her heart, all mankind she hated;
Some forty lovers sought her hand, but she baffled all their hopes,
So the forty lovers left this world by means of forty ropes.

❧

...Miss Jenkins went to the studio of Mr. Peter Guffin,
And he won her heart by taking of her photograph for nuffin,
But heartless was this man of art, to her he did confess,
That he'd won the hearts of many other nice young girls, by the very same process.

She said, "I'll be his ruin, though to perish be my lot."
Then she swallowed all his photographic chemicals and died upon the spot.
So here's a moral for all young maids, which you'll very plainly see,
Don't go to a photographic studio, for to be taken free.

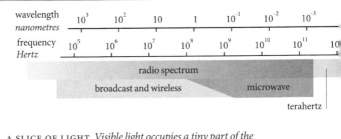

A SLICE OF LIGHT. *Visible light occupies a tiny part of the electromagnetic spectrum. In the enlarged area (opposite), red is to the left, yellow in the middle and blue on the right.*

STAY AWAY FROM THE WINDOW

A N UNUSUAL INSTANT-PICTURE camera appears in an episode of the 1960s US television series *The Twilight Zone*. A minute or so after making an exposure, it rings a bell and produces a print. So far, so unexceptional. But wait, the print it produces shows what will happen five minutes into the future. Following an antique-shop robbery, it falls into the hands of three thieves, two men and a woman, who use its remarkable properties to photograph a race-track winners' board. Armed with the future winning numbers, they smugly bet on the foregone conclusion.

Back in their hotel room, as they count their substantial winnings, and speculate on the better life to come, an argument develops between the two men. During a struggle, another picture is inadvertently taken. It shows their female accomplice screaming in panic. They continue to fight and then both fall to their deaths from the window, as the woman duly screams in panic, in a pose strongly reminiscent of that in the prophetic picture. Having calmed down, she delights in contemplating the cash, and decides to take a picture out of the window of the men lying dead on the ground, "for posterity."

A nefarious hotel waiter with a wavering French accent, intent on stealing the money, appears in the room and points out to her that the second picture shows more than two bodies in the courtyard. She rushes to the window in amazement, trips over an inconvenient wire, and plunges immediately to her death. The jubilant waiter collects up the cash, and is idly re-examining the picture, when he realises to his horror that there are actually FOUR bodies lying dead outside, and that his is the fourth corpse. Though it might have been wiser to sit in a chair and take stock of the situation, he also contrives a fatal fall from the window. Cue staccato violin music. Fade.

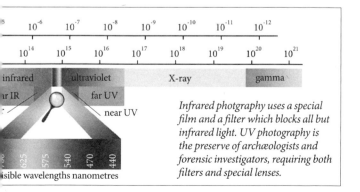

Infrared photography uses a special film and a filter which blocks all but infrared light. UV photography is the preserve of archæologists and forensic investigators, requiring both filters and special lenses.

--- HYPER REAL ---

THE USE OF PHOTOSHOP FOR deception followed smartly on from the program's introduction, though it wasn't until version 3.0, with the introduction of multiple layers, that the trickery really got into its stride. The virtuous-sounding Healing Brush tool and its blameless companion, the Clone Stamp tool have become the preferred weapons of the fashion and

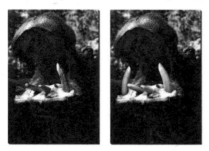

celebrity-worship magazines, along with make-up and slimming pill manufacturers. Absent from the program's galaxy of features is a flashing signal, with audio backup, to alert the operator when the degree of waistline reduction, blemish removal or breast enlargement has breached the limits of credulity.

"I always prefer to work in the studio. It isolates people from their environment. They become in a sense... symbolic of themselves. I often feel that people come to me to be photographed as they would go to a doctor or a fortune teller—to find out how they are."

RICHARD AVEDON

--- A LEAP OF THE IMAGINATION ---

PEOPLE CHANGE WHEN THEY jump in the air. Aaron Siskind shot his series *Terrors and Pleasures of Levitation* in 1956, featuring leaping bodies against a bright sky, László Moholy-Nagy photographed spheres miraculously levitated by air-jets, Jacques-Henri Lartigue encouraged his cousin to fling herself down a flight of stone stairs, but the master of "jumpology," as he named it, was Philippe Halsman. He devised a shot with Salvador Dalí, in which the latter performed a standing jump while, simultaneously, a bucket of water and three cats were thrown across the studio. A total of 28 takes ensued to get the right result. Halsman later used the technique (sans cats and water) with the Duke and Duchess of Windsor, Marilyn Monroe and Richard Nixon.

—"UNCONCERNED, BUT NOT INDIFFERENT"—

THOUGH HE ALWAYS CONSIDERED himself a painter rather than a photographer, Man Ray (born Emmanuel Radnitzsky in 1890) had an enormous influence on 20th-century photography. His self-penned epitaph (above) is a typical Dadaist brush-off. He met Marcel Duchamp in New York in 1915, helped him make his first Dadaist machine, and soon produced his own iconic *Gift* anti-sculpture, a flat-iron garnished with a row of tin-tacks underneath. However, he felt that New York was not the right environment for Dadaism—"Dada cannot live in New York. All New York is dada, and will not tolerate a rival."

Moving to Paris in 1921, Man Ray installed himself in Montparnasse, began photographing the luminaries of the European art world, and experimenting with antidiluvian photographic techniques. With his assistant Lee Miller, former fashion model and later photographer in her own right, he explored solarization and made photograms (he called them "rayographs") in the manner of Fox Talbot. His most famous photograph was made in 1924, of the painter Alice Prin (aka "Kiki de Montparnasse"). Entitled "le Violon d'Ingres," it shows her seated, bare back to the camera, with a pair of violin *f*-holes carefully drawn at waist-height. He had a subsidiary career as an avant-garde film-maker and occasional actor. In one film he is seen playing chess with Marcel Duchamp. Man Ray returned to the USA in 1940, but eventually died in Paris in 1976.

A DISC ON A WIRE *to dodge, (lighten), a part of the print and a hole in a large card to burn, (darken), a small area. Wave above the print in a confident manner.*

————————— ACRONYMS: V —————————

VR VIBRATION REDUCTION: a Nikon proprietary system built into the lens. It uses small gyros to detect lens movement and actuators to move internal lens elements to counteract the vibration. In a discreet act of largesse, Nikon have arranged the mechanism so that it only works at half strength while you compose, then at full strength on firing the shutter.

—— THE SINCEREST FORM OF FLATTERY ——

THE BEGINNING OF THE end for the European camera industry was signaled by this innocuous advertisement in the March 1938 issue of the *British Journal of Photography*. It came from the Omiya Shashin Yohin company of Japan, acting as agents for the Precision Optical Industry Co.

Ltd., makers of a Leica lookalike. The camera had been made by Goro Yoshida, a movie-camera repairman who had deconstructed a Leica II, and been surprised not to find "magical" materials inside.

The Hansa reference was to the medieval protectionist European trade league, and was apparently used in admiration rather than irony. However, it was soon dropped, and the name "Canon" appeared on its own, an adaptation of "Kwanon" (a Buddhist deity) which was on the prototype cameras.

In the chaos of 1945, the company was temporarily dissolved, but soon restarted production under the US occupation. By the mid-fifties, Canon cameras sported innovations of their own, and the range soon included the popular Canonet rangefinder camera, and the Canonflex single-lens reflex with interchangeable lenses. This camera beat the Nikon F to market by one month in 1959. Major diversification followed, into movie cameras, printers, and photocopiers. The two companies still slug it out. Canon is in the lead in terms of total equipment sales, but with Nikon slowly catching up.

AT THE CLOSE OF *the 19th century, manufacturers of the new, much smaller, "detective" cameras were concerned that users more familiar with bulky plate equipment wouldn't know how to carry them. Hence this helpful and elegant illustration.*

"The locomotives are black. The coal is black. The tracks are black. The night is black. So what am I going to do with colour?"

O. WINSTON LINK

LATON HUFFMANN WAS one of several photographers working in the Yellowstone National Park soon after its creation in 1872. He initially specialized in the extraordinary landscapes of the Park, but his later stereoscopic views concentrate on the life of ranch-hands, native Americans and the last days of the buffalo herds. He was later elected to the Montana House of Representatives, gave up the traveling life, and made a good living selling prints from his old negatives.

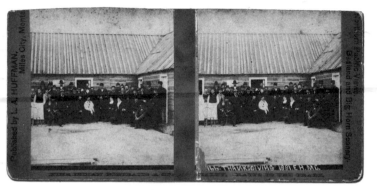

THE (PHOTO)GRAPHIC NOVEL

"SNOW WAS FALLING OVER Paris when an elderly, elegant gentleman with gaunt cheeks and pale skin opened the door to a photo gallery in the sixth arrondissement..." So begins the publisher's preamble to *Chambre Close*, a "photographic novel" of 2007, and continues, "Monsieur X is a perfectly discreet voyeur, a seducer of the Old School. Well educated and wealthy, he owns a complete set of photographic equipment and an obsessive curiosity about the female body." It is not a book for those of refined sensibility, or who appreciate skillful integration of text and images rather than flopping the words down on the left-hand page and the rude picture on the right.

However, you can avoid this kind of disappointment by producing your own photographic novel. There are several routes available. Apple's service within iPhoto, for example, gets you a hard- or softback book, pictures with captions and an authorial glow. To make your own comic-book, search for Smallzone or There Goes Tokyo. To print one book or many, try Lulu or Lightning Source. They, and many others, can produce, promote and sell your book, in physical form or as a downloadable item for use on an e-reader.

DIGITAL STIRRINGS

IN 1975, KODAK ENGINEERS at the Rochester plant were showing skeptical colleagues an eight-pound box containing movie-camera spare parts, a 100 × 100 pixel sensor, a cassette recorder, 16 NiCad batteries and some soldered circuit-boards. It was a digital camera, though needing 23 seconds to take a picture, and then to be connected to a 400-line TV to show the image.

In 1987 the US government commissioned Kodak to make the M1, designed for covert use, with the neck strap doubling as a data cable to the separate storage unit. Only one camera was produced, but it paved the way for the Hawkeye series of Nikon-based cameras. At this time, the company called all such cameras "imaging accessories," as they were unwilling to be seen as promoting an alternative to film.

The DCS series, still using Nikon bodies, appeared during the 1990s, aimed at the professional user with the slogan "convert to a new digital system without switching cameras." New models began to appear with internal hard drives and higher-resolution sensors. Kodak's sensor technology was also incorporated into backs for Hasselblad and Mamiya cameras. The DCS line itself came to an end in 2004, and the sensor division is now part of digital back-maker Aptus Leaf.

> *"I can't say the brassière will ever take as great a place in history as the steamboat, but I did invent it."*
>
> CARESSE CROSBY,
> sometime lover of Henri Cartier-Bresson

A CURIOUS DARKROOM HABIT

NO-ONE KNOWS WHO discovered this trick, but it's still in use in darkrooms. The skin on the human nose secretes a waxy substance which has a similar refractive index to gelatin. A scratch on a negative can therefore easily be filled in, if not eradicated entirely, by a judicious gesture of the finger. Also apparently useful as a light lubricant for mechanical camera gears.

SCISSORS AND PASTE. *The traditional boastful postcard cargo is a 30-foot Idaho potato but, in this case, the monster oranges of California get an outing on the Southern Pacific railroad.*

ACRONYMS: W

WB WHITE BALANCE: a filter or in-camera maneuver to remove a predominant color cast, and approximate a "daylight" appearance. See page 39 for the Kelvin color-temperature scale. Using the Raw format (*see p. 27*) with a digital camera allows white balancing to be done later in an imaging program.

EXTENDED DEVELOPMENT

HENRI CARTIER-BRESSON WAS born in 1908 and trained extensively as a painter: the inspiration that pushed him into photography was a picture by Martin Munkacsi. Cartier-Bresson recalled, "...when I saw the photograph of Munkacsi of the black kids running in a wave, I couldn't believe such a thing could be caught with the camera. I said damn it, I took my camera and went out in the street."

He photographed with a passion, but his first work as a photo-journalist was not published until 1937. The spur for this change of direction was David Seymour (*see p. 33*). Cartier-Bresson escaped his POW camp in 1943 and dug up the Leica he had buried shortly before the invasion. Following the war he worked for *Life* magazine, covered Gandhi's funeral and worked extensively in the US, China and the former Soviet Union. In 1970, he largely gave up photography and returned to drawing, saying, "photography has never been more than a way into painting, a sort of instant drawing."

AMATEUR PHOTOGRAPHY: Arthur Burdett Frost, an illustrator now revered as one of the fathers of the comic-strip genre, takes a swipe at the photographic craze (and the yokelry of rural America). Printed in 1884, four years after the first appearance of a newspaper half-tone photograph, and shortly

before the introduction of the Kodak camera, it skewers the disadvantages of photography. Frame 5, for example, "Some Results," shows lens distortion and unwanted subject movement, and frame 8 is labeled "He went on to photograph the yacht race, but...!" From *Harper's Weekly*, August 1884.

We are prepared to furnish our Patent Stamp outfits to the trade. No enterprising photographer should be without one; it will increase your business, advertise you and help you financially.

TIRED OF ENDLESS *step-and-repeat printing? Just slip a picture into the copying frame, shoot, and it's done. The Stamp Portrait Camera of 1888 came with up to 25 lenses and a perforator for dividing the finished print into individual stamps.*

WAR IS OVER

RAY MORGENWECK WAS one of a number of photographers working at historical re-enactments in the USA. These occasions are usually held to commemorate Civil War battles, and the photographers operate in authentic costume, using only contemporary processes and original or replica cameras. However, it may rain, and as a result there may be rather few people who are willing to pay to pose in their muddied uniforms for a battlefield portrait. Ray Morgenweck eventually retired from the mud to his workshop and re-invented himself as a camera-maker. These are working machines, handmade of hardwoods and brass to the original specifications, and usually requiring only a lens to complete. In his list he offers the following, not necessarily from stock, but soon:

The original Niépce, of 1826, from ancient mahogany.

Fox Talbot's "mousetrap," so named by his wife, made from chestnut.

The 1843 Chamfered Front Daguerreotype, the first American-designed camera.

The UnLeica. Made of wood for 2½" × 3" format. Not much like a Leica, but equally simple to use.

The Anthony 8" × 10" bellows camera, converts to whole plate and 5" × 7". Cherry or Mahogany.

The Mammoth 22" × 22", especially for ambitious landscapes.

La Petite Demoiselle. A new lightweight 5" × 7" design, in Red Cedar.

A sturdy, padded, adjustable posing chair in the Victorian style.

> *"There are no bad pictures; that's just how your face looks sometimes."*
> ABRAHAM LINCOLN

IKONIC

THE FORTUNES OF THE Zeiss brand exactly mirror the international stresses and fractures of the 20th century. In 1847 Carl Zeiss was a microscope maker in Jena. Optical scientist Ernst Abbe joined him in 1886 and inherited the firm when Zeiss died two years later. Abbe created the Carl Zeiss Foundation, still in existence, though not in the camera business.

From 1926, Zeiss became the parent company of a group of camera makers under the name of Zeiss Ikon, and this was the event that ultimately produced the celebrated Contax rangefinder camera in 1932. It competed directly with the Leica, but employed a different mechanical approach. The focal-plane shutter is made of interlocking brass slats and runs vertically, on the short axis of the film frame. The idea was to obtain a higher maximum shutter speed, even though there was no film available at the time which was fast enough to benefit. The revised Contax II and III followed, but the Dresden factory was severely damaged during World War II. Russian forces expropriated most of the tooling to Kiev to establish their own camera production, while US forces took key Jena staff to Stuttgart in the newly created West Germany.

Zeiss thus became two companies, in Jena in the East and Oberkochen in the West. Both continued to make cameras and lenses, fought endlessly over trademarks, and were re-united in 1990. Joint projects were hatched with Yashica and then Kyocera, the latter producing a Contax SLR which survived until 2005. Zeiss now makes microscopes, lenses, and spectacles. The Russians carried on making their "Kiev" Contax until 2009.

ACRONYMS: X, Y, Z

X: shutter-speed setting to ensure synchronization with electronic flash, significant only for focal-plane shutters.

Y2K THE MILLENNIUM BUG: photography suffered along with the rest of the world on January 1st 2000; in other words, not very much. The next significant event is awaited on Thursday January 1st 2038, when Unix-based 32-bit computer systems may go into meltdown because they are based on a timing régime which will run out of digits on that day. Disappointingly, there are no photographic acronyms beginning with Z.

INDEX